IMAGES
of America

PLAINVILLE

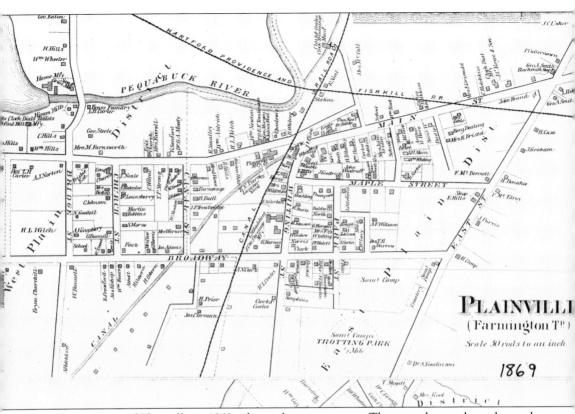

This is a map of Plainville in 1869, when it became a town. The map shows where the settlers lived and where businesses were located.

On the cover: The Horace Johnson Carriage Shop and showroom was located on Whiting Street around 1884. (Courtesy of the Plainville Historical Society.)

IMAGES of America
PLAINVILLE

Lynda J. Russell

Copyright © 2007 by Lynda J. Russell
ISBN 978-0-7385-4959-0

Published by Arcadia Publishing
Charleston SC, Chicago IL, Portsmouth NH, San Francisco CA

Printed in the United States of America

Library of Congress Catalog Card Number: 2006935107

For all general information contact Arcadia Publishing at:
Telephone 843-853-2070
Fax 843-853-0044
E-mail sales@arcadiapublishing.com
For customer service and orders:
Toll-Free 1-888-313-2665

Visit us on the Internet at www.arcadiapublishing.com

Dedicated in memory of Chester Irving Russell, born in Plainville on May 28, 1914, and died June 17, 1991. He had started doing the history on his family before they came to Plainville, but he never had a chance to finish it.

Contents

Acknowledgments		6
Introduction		7
1.	The Great Plain Settlement	9
2.	Around the Town	29
3.	Manufacturers	43
4.	Business	55
5.	Transportation	67
6.	Those Special People	77
7.	Serving the Public	87
8.	Changing Times	99
9.	Social Clubs, Organizations, and Entertainment	117

ACKNOWLEDGMENTS

I would like to take this opportunity to thank the following individuals or businesses that provided information and pictures for this book: Wheeler Clinic, Martha Couture, Andrea Wasley, Steve and John Parsons, Wheeler YMCA, Signe Heorle Guzzo, John Everett, Frank Corbiel, Roy Roccapriore, Jean R. Jeanfavre, Bob Guerriere, and Bill Petit.

I would also like to thank Ruth Hummel for all the months we spent going through material and for allowing me access to files that made it so much easier to research materials I needed to complete this book. And last of all a special thanks to my husband, Chet, for all his help and support through it all.

A portion of the proceeds from this book will go to the Plainville Historical Society and its scholarship fund.

INTRODUCTION

Plainville was the last town to separate from Farmington and was originally known as the Great Plain. Two rivers run through the town, the Pequabuck River that flows northeast through Plainville to join the Farmington River in Farmington, and the Quinnipiac River that flows south to Long Island. The Pequabuck River would play an important part in the growth of the town.

The settlement of the Great Plain developed slowly due to poor soil compared to Farmington's rich meadows. In 1695, two roads were laid starting from Farmington to White Oak Plain and another to Great Plain. Land was granted to the original 84 proprietors of Farmington, who divided the land granted to their descendants. One of the first settlers, John Root, arrived in 1657 and built his home in the White Oak section. Thomas Lowrey, Moses Hill, John Hamblin, Elizabeth Newell, Asahel Hooker, and Moses Morse settled in various areas, including Red Stone Hill and White Oak.

Aside from farming, others started businesses. In 1778, Samuel Demming started a sawmill and gristmill near the Pequabuck River. The manufacturing of tinware was begun on Red Stone Hill by Lewis Foot, Asahel and Ira Hooker, and the Bishop family near their homes. Moses Morse, a Revolutionary soldier, settled here in 1807 and was a carpenter by trade who made chairs, brooms, rolling pins, and wooden combs for women's hair.

It was the planning of the Farmington Canal in May 1822 that helped the growth of Plainville. George Mitchell and Thomas Barnes Jr. of Bristol, Samuel Deming from Great Plain, and New Haven merchants planned a canal to run between New Haven and Northampton, Massachusetts, bypassing Hartford. The Farmington Canal Company began construction in 1825 and opened for business in 1828. In 1828, Adna and Ebenezer Whiting bought land near the canal route and dug a basin where canal boats could dock. It was known as Whiting's Basin, located on East Main Street and Farmington Avenue. In 1830, they sold the property and built the Bristol Basin on West Main and Whiting Streets. They built a general store and a dock for the boats. In 1834, the Welch brothers from Bristol started a mercantile business on the opposite bank of the canal. A number of boats were built in Plainville, including the *H. M. Welch* that was used for transporting goods from the Welch mercantile store. The Farmington Canal did not prove to be a financial success due to washouts, droughts, and damages to boats; and the canal itself proved to be a financial burden to both the banks and stockholders. In 1846, the stock of the canal company passed to the control of parties from New York who secured a charter for a steam railroad to be operated from New Haven to Northampton, Massachusetts. Gradually the canal was filled in. General stores and other businesses that were connected to the canal continued to prosper.

In 1829, an application for a post office was filed, and in 1830, when the new postmaster was appointed, the village was named Plainville. Bristol Clock, a brass foundry, started in 1839 making keys and parts for clocks. Plainville Manufacturing Company started in 1850 making knit underwear and other knit goods and was located on Main and Pierce Streets. Carriage makers Johnson, Webster, and Gladding were some of the manufacturers in town who sold to other parts of the country.

Plainville incorporated in 1869. As a new town many improvements were made. District schools combined in a new building, and surveyors laid out new streets as the town was growing. The Hook and Ladder Company, which provided fire protection, and the library started. In 1899, Trumbull Electric Manufacturing Company was started by brothers John and Henry Trumbull and Frank Wheeler. John Trumbull would become governor of Connecticut and serve three terms. Robertson Airport was started in a field owned by the Tyler family in 1911. Plainville evolved from a small village of only nine and a half square miles to a modern town with many family-owned businesses and large industries that continue to grow.

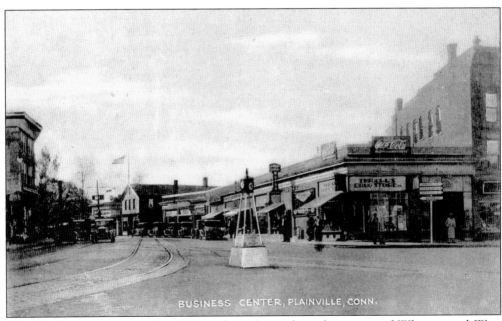

Thrall's Drug store opened in 1923 and was located on the corner of Whiting and West Main Streets.

One
THE GREAT PLAIN SETTLEMENT

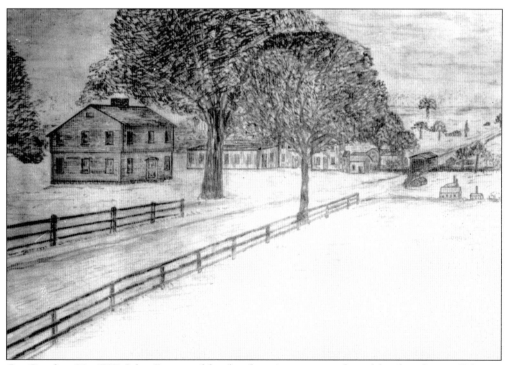

On October 30, 1797, John Root and his brother Artemas purchased land and a small house located on North Washington Street. Artemas lived in the house and operated the first hame shop near his home.

Deacon Lucas Hart Carter purchased six acres of land near the covered bridge on North Washington Street and started a brass foundry there. He married Jane Stanley, daughter of Deacon Roderick Stanley. Carter helped build the first meetinghouse for the Congregational Church. Carter died in 1880.

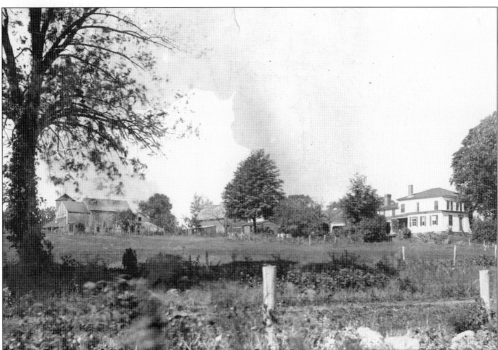

Thomas Lowrey from Ireland and his wife, Mary, came to Plainville in 1740 and built this home and farm on Red Stone Hill. When Thomas died in 1788, his son Samuel continued to lived here.

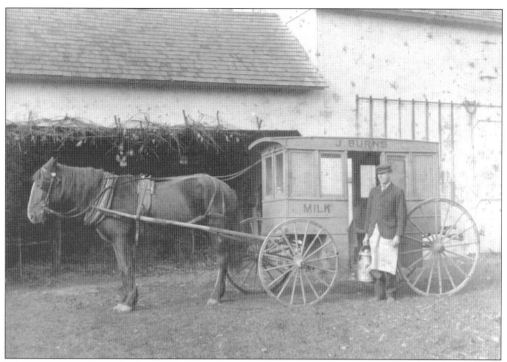

John Burns purchased Thomas Lowrey's property on Red Stone Hill. In this picture is a milk wagon that Burns used to deliver milk and dairy products from his farm.

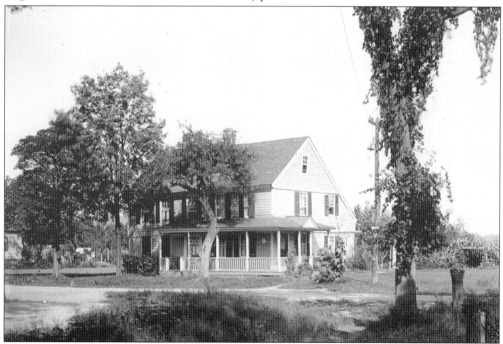

This is the home of Moses Hills, who was the first of his family to come to the Great Plain in 1747. The home was located on the corner of East and Broad Streets. Today a dentist office stands in its place.

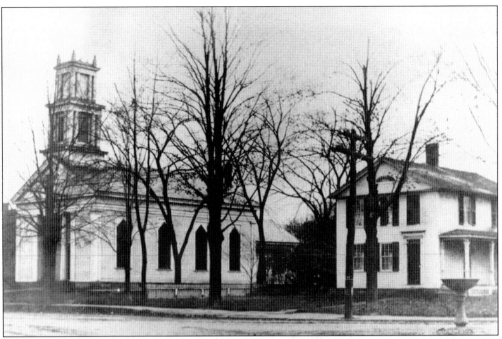

In the above picture on the left is the Baptist church and Adna Whiting's home is on the right, located on East Main Street. Whiting's house was later torn down.

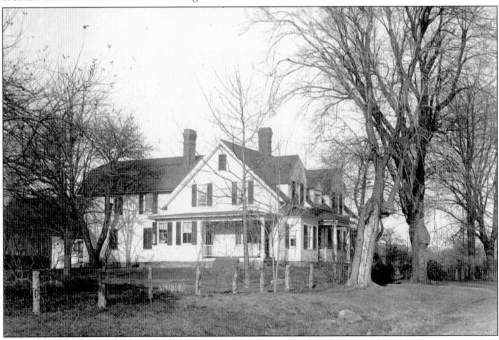

This home was built by Asahel Hooker in 1774 at 135 Red Stone Hill. Asahel was a fifth-generation descendant of Rev. Thomas Hooker of Hartford. Asahel and his sons Capt. Bryan Hooker and Deacon Ira Hooker were manufacturers of tinware, working near the house. The original property was 45 acres, and the house had eight rooms. It is the oldest house in Plainville and remains a private home today.

Built in 1790, this is the home of Phineas Cowles. He gave 10 acres of land, including the house, to his son Rufus. The property was located on North Washington Street.

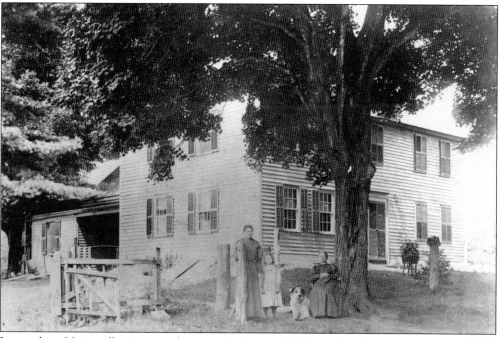

Located on Unionville Avenue, this was the home of William Cowles Sr., built around 1896. The young girl in the picture in Jennie Tyler Cowles.

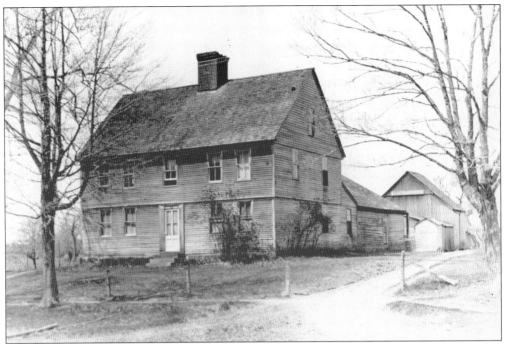

This home was built by Deacon Ira Hooker and his wife Amy Barnes Hooker on Red Stone Hill in 1791. Ira was the son of Asahel Hooker. Ira and Amy had five sons and five daughters. Ira was elected a deacon of the United Congregational Church of Bristol in 1808. The property consisted of 155 acres, most of it was farmed. Ira died in 1838. The home is a private residence today.

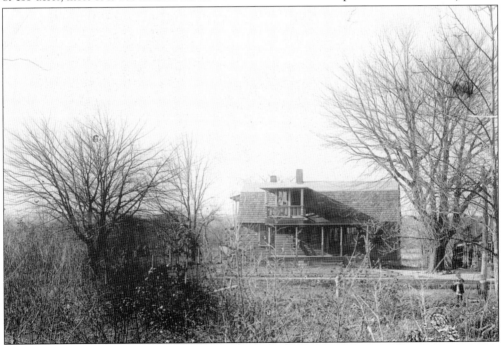

Deacon Ira Hooker started making tinware with his father, Asahel. Ira started his own business on his property on Red Stone Hill. The picture shows his tin shop that was located behind his home.

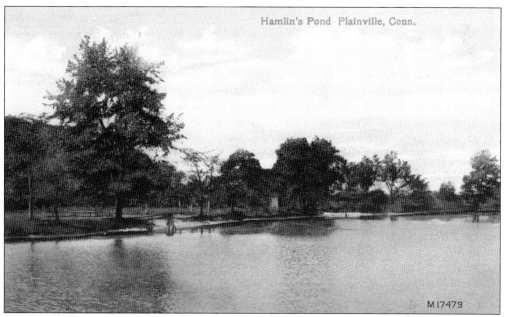

As early as 1695, land near the Great Pond was granted from the original proprietors to the Root, Wadsworth, Porter, Scott, and Hooker families who either built their homes or exchanged for another area. It later became known as Hamlin's Pond, located in the White Oak section of the Great Plain.

This was the home of John Hamblin and his wife Eleanor Orvis Hamblin. After they were married in 1758, John bought land in 1761 in the White Oak section from Joseph Hooker. John lived here until he died on November 26, 1821.

Phineas Hamblin built this home around 1789. His brother Oliver also built in the same area known as New Britain Road. They were sons of John Hamblin, a Revolutionary War soldier. In 1816, Chauncey Porter lived in the home. The house had residents living in it up to the 1960s, making many changes. In the 1970s, it became a used-book store. The store closed in 2001 and the building sits empty across from Connecticut Commons on New Britain Avenue.

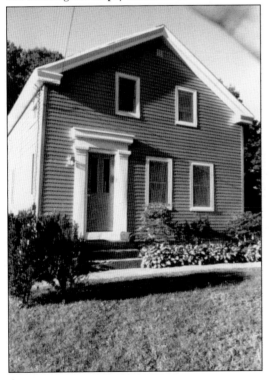

This Greek Revival home built around 1854 on 86 Broad Street was the home of John Prior. Prior worked at Usher and Tinker, makers of sashes, doors, and blinds, which leased its property from Edward Noble Pierce from 1883 until 1887. Thomas McCall, an employee of E. N. Pierce Company, lived in the house from 1915 to 1922. Today the home remains a private residence.

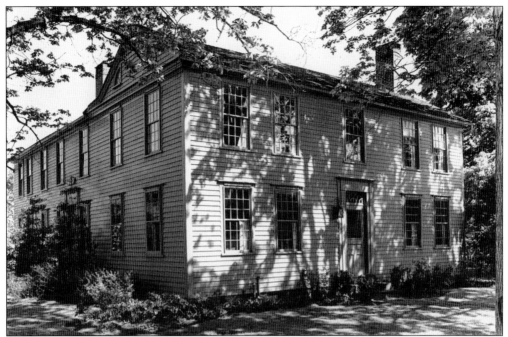

Jarvis and Artemas Root from Southington purchased 115 acres of land and a house in 1803 from Cuff and Benjamin Freeman for $1,540. Jarvis and his wife, Sarah, would acquire this property. In 1841, their son John J. Root became owner. The house on 73 West Main Street is the law office of Koskoff and Nielson.

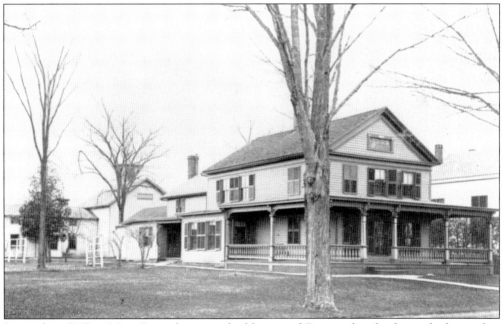

Located on 50 East Main Street between the library and Baptist church, this is the home that was built by Levi Beach in 1849. Beach was a clock maker and a partner in Plainville Trading Company when the Farmington Canal was operating. A fire destroyed the home in 1981, and it was torn down in 1982.

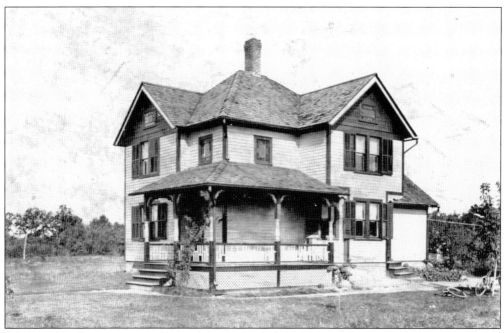

Built in 1914 on Woodford Avenue, this was the home of Frederick John and Hattie L. Norton Russell. Frederick was born in 1863 and was the son of Josiah and Eliza Russell. Frederick worked as a watchman at the Edwin Hills Manufacturers on North Washington Street. He died in 1943. The house was torn down in 1985.

Hattie L. Norton, born in 1873, was the daughter of David A. Norton of Plainville. She was the second wife of Frederick John Russell. They had five children: Charles Wesley, Louis Vernon, Flora Gertrude, Chester Irving, and Herold. Hattie died on June 17, 1920, at the age of 47.

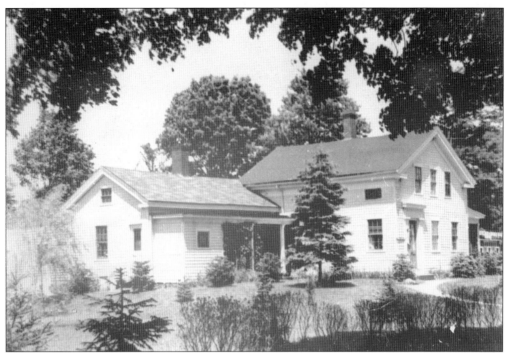

Located on East Main Street near Norton Place, this was the home of Charles Norton's family. It was used by the abolitionists for the Underground Railroad. Frank Hartford was the next owner of the house. It was later torn down for a parking lot for Peterson's Inn.

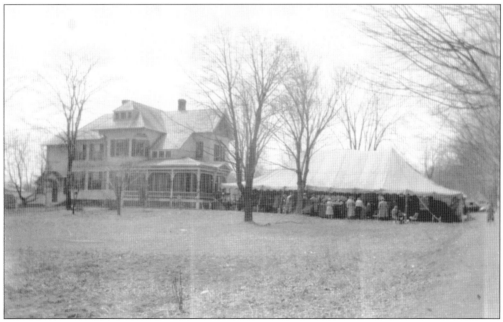

This home was built for Mary Fenn and her daughters Rosa Bell Fenn Oldershaw and Mary Eloise Stephenson in 1892 on 206 Broad Street. Walter Oldershaw, an antique dealer, owned the house next. In this picture, a tent is set up to auction off the contents when Walter was selling the house. The house is a private home today.

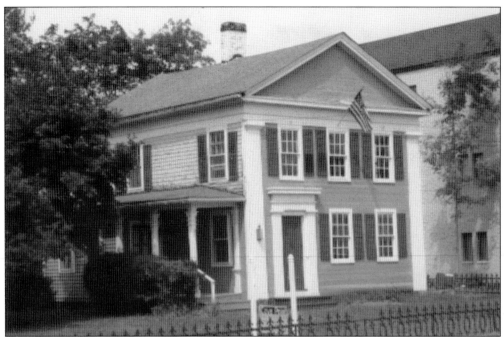

This home was built in 1821 for J. Sanford Corbin, a carriage maker who owned a shop farther down on Whiting Street from his home at 50 Whiting Street. He was married to Sarah Webster, daughter of Ebenezer Webster. The fence in front of the house came from a boardinghouse on East Main Street. Corbin continued his trade until he died in 1911. The house still stands today.

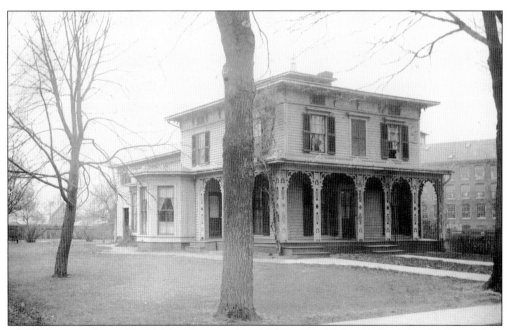

This home stands on 47 Whiting Street around 1909. The Plainville Knitting Mill on Main Street is in the background on the right. Today J. P. Jewelers stands in its place.

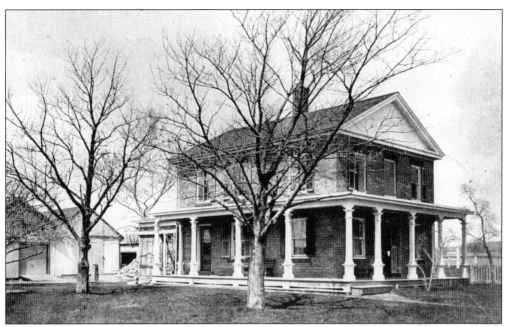

Located at 105 North Washington Street, this is the home of George W. Eaton around 1850. In 1876, Eaton and Andrus Corbin ran a gristmill under the name of Corbin and Eaton. In 1878, Eaton purchased the business as a commercial feed and flour mill. He died in 1906. His sons James A., Herbert W., and William S. continued the business as the Eaton Brothers. The house still stands today.

Built around 1865 at 136 East Street, this was the home of Dr. Simon Tomlinson. Tomlinson was a dentist by profession. He had many other interests, including being the editor of the *Plainville News*. When Plainville petitioned to separate from Farmington in 1869, Hiram Hills spoke of Tomlinson as a learned and able professional. Tomlinson Avenue was named after the doctor. The house still stands today.

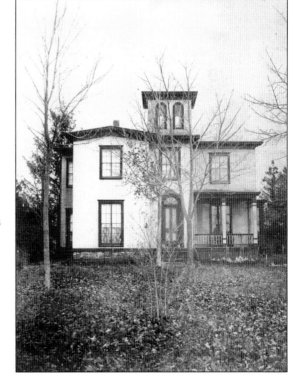

The house at 107 South Washington Street was the home of Josiah John Russell. He built the home in 1839. It was located next to the Farmington Canal where Josiah worked on the canal boats. The house still stands today.

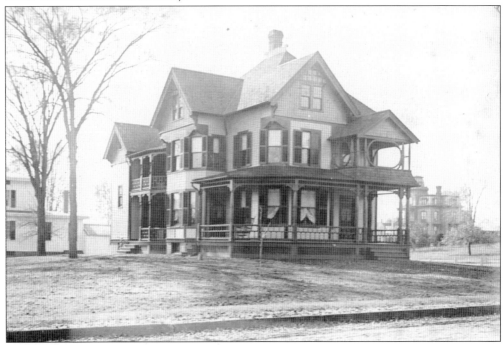

This home on the corner of West Main and Washington Streets was the home of Andrew J. Norton. He was known as "Captain Dick." He was a captain on the *Ceres* boat owned by Adna Whiting. The home was built around 1890 and still stands today.

Hiram Hills was born in Plainville on October 9, 1810. He was the son of Elias and Sally Curtis Hills. In 1835, at the age of 25, Hiram was the first to manufacture carriages. He built his factory on North Washington Street near Plainville Pond. He was a signer of a petition by the new Congregational Church in Plainville to separate from Farmington. He was first married to Betsey A. Ludington and had seven children. His second wife was Olive Augur. Hiram died on June 25, 1875.

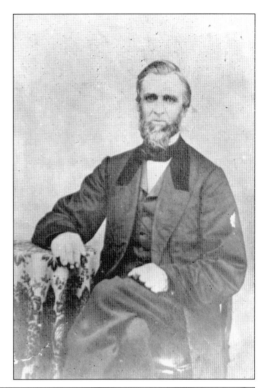

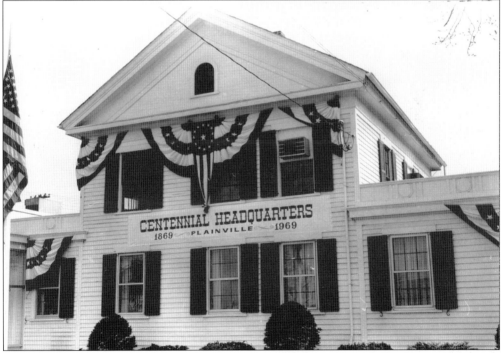

Located on West Main Street, this was the home of Hiram Hills. The house was used during Plainville's centennial in 1969. It was torn down when Southern New England Telephone put its building up.

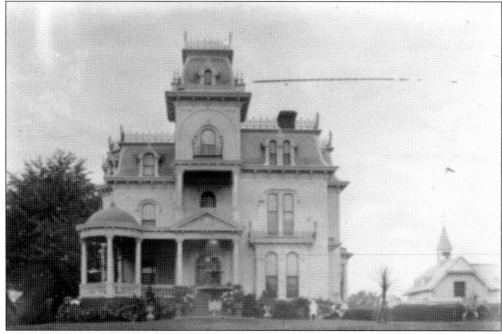

This is the home built on Washington Street for Edwin Hills in 1872, shortly after his marriage to Emma Bullen. Edwin was the son of Hiram Hills, who was one of the first settlers in Plainville. Edwin worked for a while in his father's carriage business and then went into the hardware business. The mansion had 13 rooms, along with barns, greenhouses, and a coachman's cottage on six acres of land. In 1952, the mansion was torn down. All that remains today are the pillars on the street now known as Hillcrest Drive, named in honor of the family.

Emma Bullen Hills, wife of Edwin Hills, was born in 1863 in Plainville. She was the second wife of Edwin. They had one child, Edwin Hiram Hills, born in 1883. Emma died in 1960.

This was the home of Clarence Woodford. He owned from East Street to the Quinnipiac River. Besides farming, Woodford ran a coal, ice, and gravel business. He would get the ice from Hamlin's Pond. The property later became Lone Pine Tourist with Jesse Byington as its proprietor. Woodford Avenue was named in Clarence's honor.

Henry Arthur Gould, son of Henry John Gould, grew up in the Amenia-Millbrook area of New York. His family purchased a farm at 204 West Main Street in Plainville after a short time in New Britain. Henry Arthur, known as Arthur, started a poultry business with his father. Arthur married Helen Chute in 1931. They had two children, John and Gertrude. Arthur died in 1955 at the age of 64.

Hugh H. Trumbull was born in Ireland in 1847. He came to the United States in 1872. He was married to Mary Ann Harper, also from Ireland. They came to Plainville in 1888, and Hugh was a farmer. They had seven sons: John Harper, Henry H., Frank Samuel, Alexander Hugh, James, Isaac Blair, and George Rea. Hugh died in 1922.

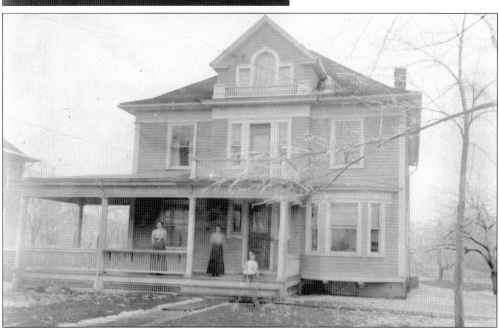

Located at 11 Farmington Avenue, this was the home of Hugh and Mary Ann Harper Trumbull. It was built in 1903 and torn down when Route 72 was built.

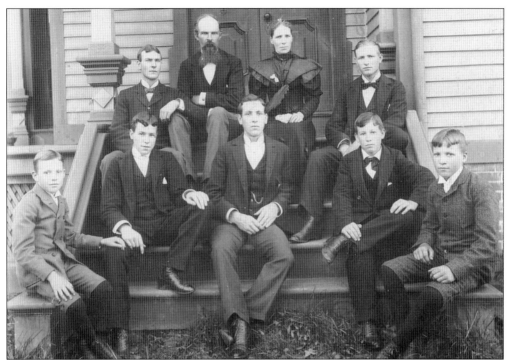

This is a family picture of the Trumbulls. From left to right are (first row) George, Alexander, Henry, James, and Isaac; (second row) John, Hugh, Mary Ann, and Frank.

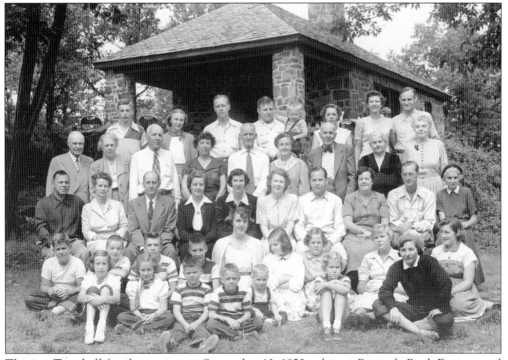

This is a Trumbull family reunion on September 10, 1950, taken at Pinnacle Rock Farm owned by Henry Trumbull.

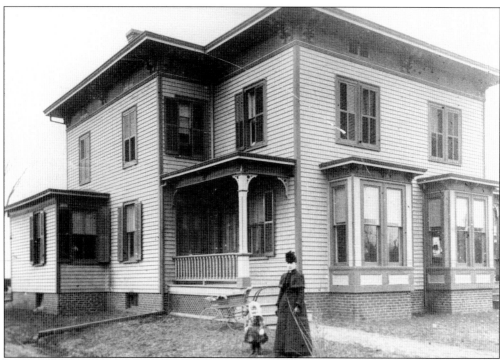

Lucy Peck bought this property on 81–83 East Main Street in 1878. The house was built around 1880. Peck never lived in the house. An early tenant was William Clark, who was a traveling salesman.

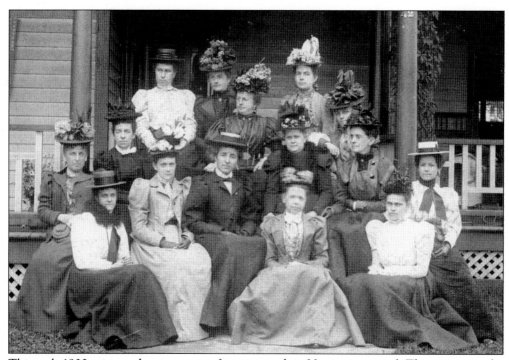

This early-1900s picture shows a group of women in their Victorian apparel. The woman in the sailor hat, front center, is believed to be Merritt Ryder.

Two

AROUND THE TOWN

George Cooke, son of John Cooke, was born in 1788. George went into the military to fight in the War of 1812. His brother John H. Cooke was a blacksmith. George came home and became active with his brother to help petition for a post office. George had two children, George Cooke II and Mary. George Cooke died in 1864.

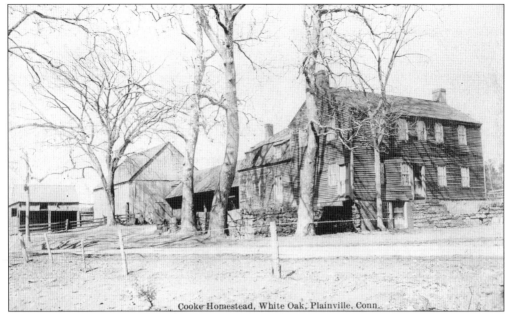

This home was originally owned by Luther Shepard of Farmington. He sold the property to John Cooke in 1795. There was a shed and a large barn to the left of the house. Originally the house contained six rooms, with a ballroom. There was a kitchen in the basement that was later used as a blacksmith shop until 1880. After it became a tavern, many changes were made through the years.

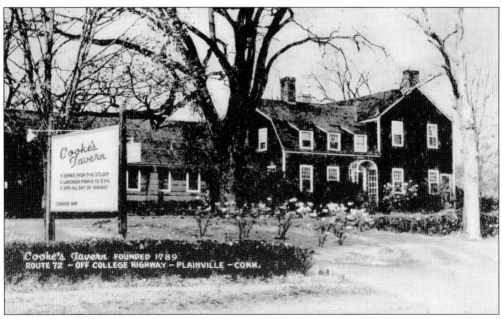

This 1930s picture of Cooke's Tavern shows a very different look from the original home of John Cooke in 1795, when he lived in it.

George Cooke II, grandson of John Cooke, lived in his grandfather's house from 1832 to 1923. Injured as a child, he lived an active life enjoying gardening and making dairy products. He loved horses and was a member of the Grange. He never married, and upon his death in 1923, the property was deeded to his sister Mary's daughter Lillian West Kirkham.

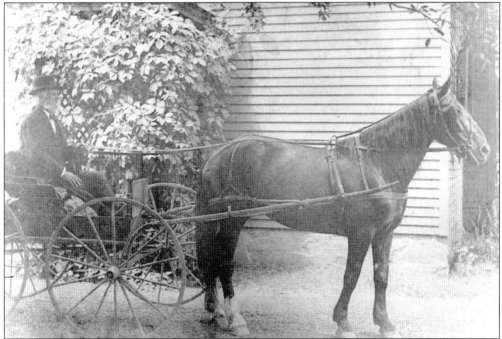

This picture shows George Cook II ready to take a ride in his buggy around 1920.

This tavern was built in 1829 for the purpose of providing food, drink, and lodging for people on the canal boats. When Ebenezer Whiting found out the Farmington Canal would cross this land, he purchased five acres in 1826 from his father-in-law, Josiah Hotchkiss, and excavated a basin to accommodate the canal boats and a warehouse. It became known as Blossom's Tavern. Later it became the first post office and then a private residence. In the 1930s, Isaac Albert purchased the property for a furniture store called Plainville Wayside and then Pilgrim Furniture. In 2002, the building was torn down. Today a Walgreens drugstore stands in its place.

On the left is Blossom's Tavern, on the corner of East Main Street and Farmington Avenue, as it looked in early 1900. The house on the right is now where Anthony's Service Station is.

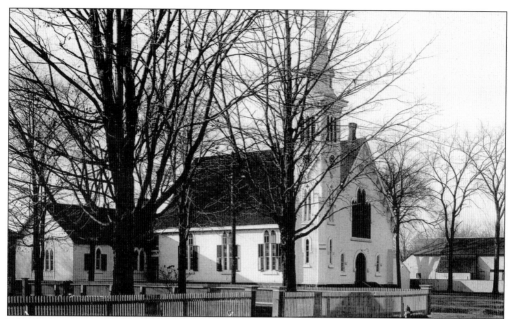

The Congregational Church of Plainville, located at 130 West Main Street, was first organized in Plainville by members of the Farmington Church in 1839. A committee of William Ives, Roderick Stanley, Lucas H. Carter, Chauncey Morse, and Rufus Cowles was involved in the construction of a meetinghouse on land purchased by William Ives from Benjamin Bird. The meetinghouse was on the corner of Main and Canal Streets. The bell for the tower was brought on a boat on the Farmington Canal. The first service was held in 1840. Within 10 years, the congregation outgrew its building, and this church was built in 1850.

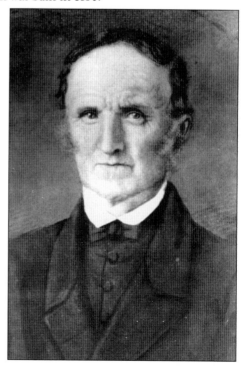

On April 5, 1821, Deacon Roderick Stanley of Plymouth came to Plainville. Through the efforts of Stanley and other members, the new congregation was formed on March 17, 1840. Roderick Stanley and Rufus Cowles became the first deacons. The first service was held on April 12, 1840.

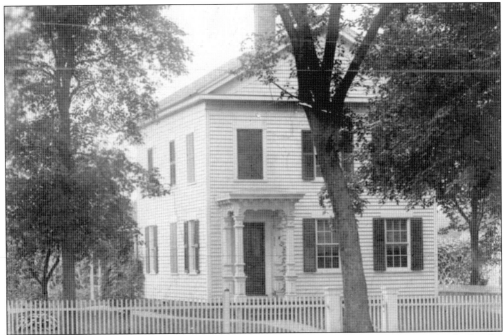

It was during Rev. Joel L. Dickinson's pastorate in 1853 that the parsonage was built for the Plainville Congregational Church on land deeded by Roderick Stanley, Byran Churchill, Samuel Camp, William Cowles, Joel Dickinson, Hiram Hills, Levi Beach, and Lucas Carter.

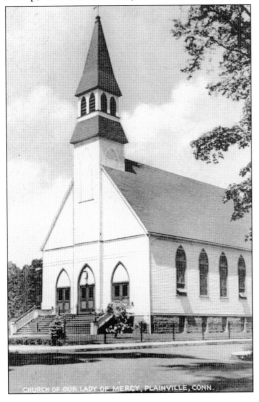

Our Lady of Mercy Church held its first mass in 1848 by Fr. Luke Daly. Various homes and halls were used to conduct services. The church was established in July 1881. The first church was built in 1881 on land donated by Edward Noble Pierce. It was located on the corner of Pierce and Broad Streets. In 1957, the church moved to Broad and South Canal Streets. In its present location, a rectory and later a school were added.

The Baptist Church was organized in 1851. Adna Whiting helped establish the church by having the first meeting at his home on East Main Street. Once funds were raised, the church was built at 18 East Main Street on land owned by Adna Whiting. His house was next door. The church still stands in the same place today.

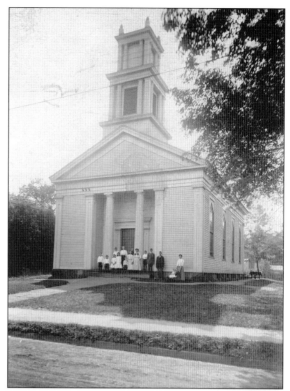

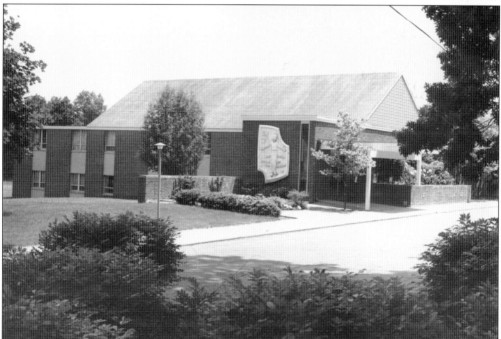

In 1859, the Methodist Episcopal Church was organized. The first church, built in 1881, was located on Broad and Canal Streets. It moved to Red Stone Hill when the present church was built in 1964. The church today is known as Plainville United Methodist Church.

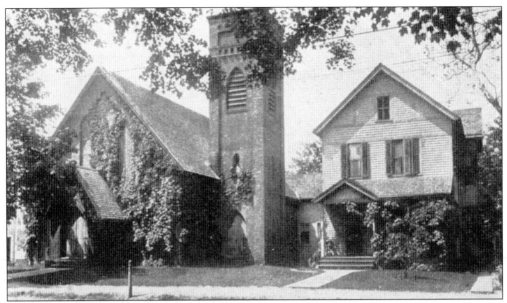
Located at 115 West Main Street, the Episcopal Church of Our Savior started in 1859. This picture shows the church, parish house, and rectory.

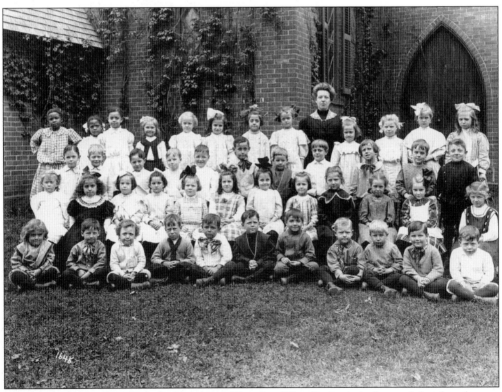
This kindergarten class from the Episcopal Church of Our Savior is in front of the church.

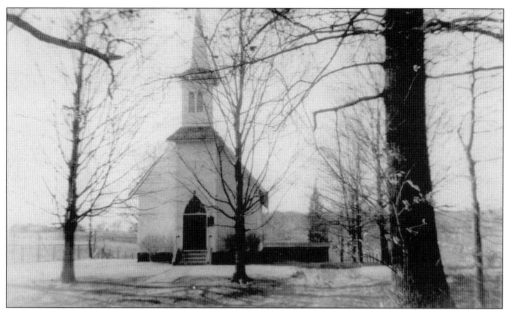

The Swedish Congregational Church, erected in 1881, was first used as a Methodist church. It was located on Camp Street. On September 25, 1942, a tornado came through Plainville and demolished the church.

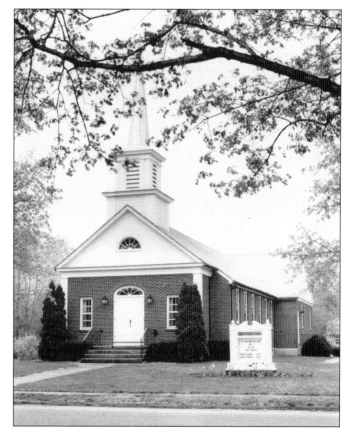

After the tornado, the Swedish congregation reorganized in 1895. It became Trinity Covenant Church, located at 59 Trumbull Avenue.

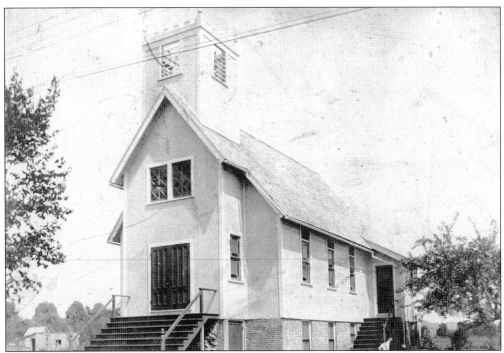

Redeemer's African Methodist Episcopal Zion Church was first organized by Douglas Mason in 1896 when he purchased land on West Main Street. The land was cleared for a building but was abandoned. On September 23, 1900, Rev. J. R. Cannon of New Haven and Samuel Baker of Plainville started a church using the Methodist church for their services. Then they moved their church services to Alderiege Block on Whiting Street. Other locations were used until land was purchased on Whiting Street and the meetinghouse was built on June 19, 1904. The church was dedicated on September 4, 1904.

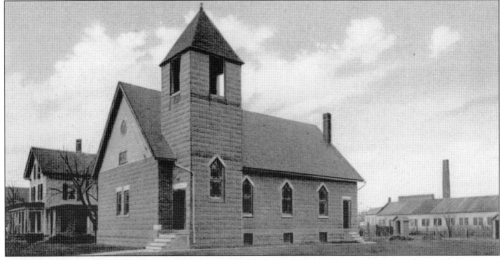

Advent Christian Church was organized in 1902. From 1900, when Rev. John S. Purdy came to Plainville, until the church was built, Purdy conducted church services in George Newton's store on Main Street. The first church was located on Broad Street. In 1966, the church was abandoned. A new congregation was formed along with a new church built on Unionville Avenue.

A group of individuals purchased this home that belonged to Charles N. Norton at 160 West Main Street on April 14, 1949, for the Church of the Bible and parsonage. At the time, Rev. Paul Johannsen was the minister.

As the congregation increased, the Church of the Bible tore down the house and built this new church in 1970.

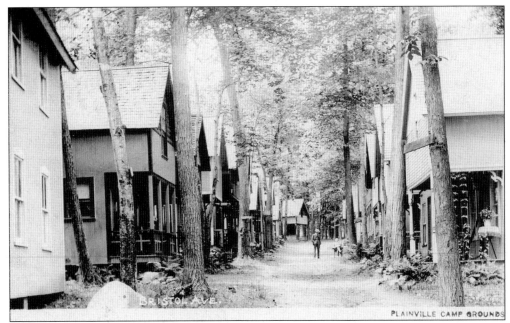

Plainville Campground, located on Camp Street, was started by the Methodist Church from New York State in 1865 for the purpose that religious travelers could come for prayer meetings. The meetings included pitching tents and spending several days in prayer. Later cottages replaced the tents. There are 114 dwellings on 26 acres of land. In 1980, the campground became part of the National Register of Historic Places.

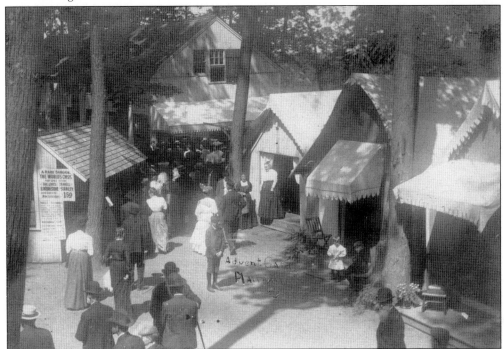

This 1907 picture shows canopies on some of the cottages. Today 75 of the cottages are privately owned, and the remaining 39 are owned by various churches.

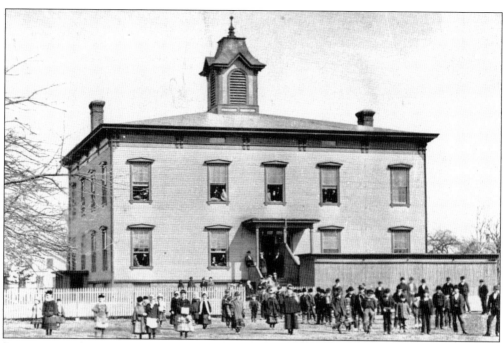

Prior to 1874, children attended one of three district schools in town. When Broad Street School opened in 1874, the children attended this school. As the town grew, an addition was built in 1911. The school's name was changed to Torrant School, after Ann V. Torrant, who started teaching here in the 1920s. Today the building is Torrant House Apartments.

This early-1900s picture shows the teachers in front of Broad Street School.

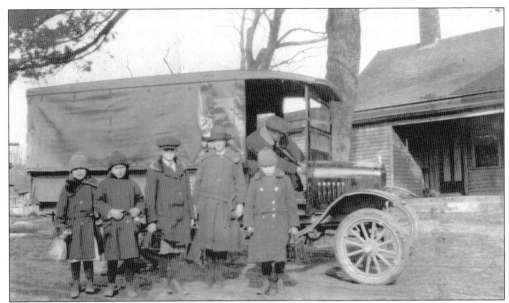

Tyler farm used its truck to transport children from the North Washington Street area. They would put wood planks inside so the children would have a place to sit. The school they went to was Broad Street School.

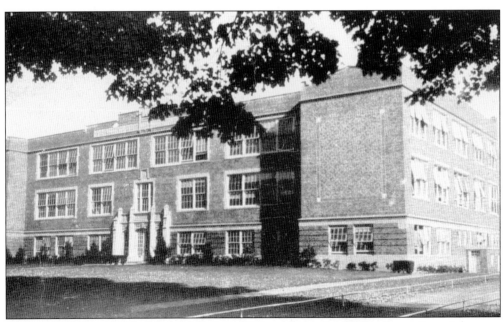

This was the Plainville High School, built in 1926 and located at 74 East Street. Later it became the junior high school when the new high school was built. In 1992, the school closed. Manafort Brothers purchased the school in 1999, making it into offices while still preserving its exterior.

Three

MANUFACTURERS

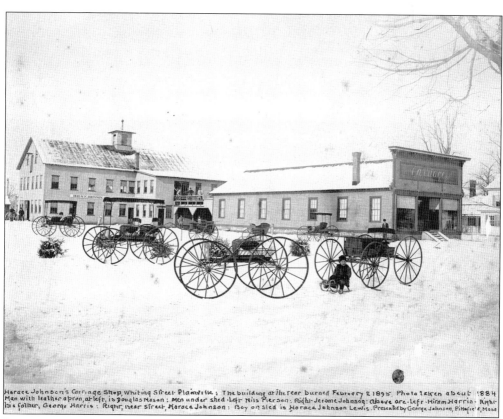

Horace Johnson's Carriage Shop, Whiting Street, Plainville; The building at the rear burned February 2 1895. Photo taken about 1884. Man with leather apron, at left, is Douglas Mason; Men under shed, Left: Nils Pierson; Right: Jerome Johnson; Above are: Left: Hiram Harris - Right: his father, George Harris; Right, near street, Horace Johnson; Boy on sled is Horace Johnson Lewis. Presented by George Johnson, Pittsfield, Mass.

Born on December 25, 1822, in New York, Horace Johnson came to Plainville in 1844. He formed a partnership with L. S. Gladding making carriages and buggies. The factory was located on Whiting Street. It was a very successful business known throughout the East Coast. The factory burned down in 1895. Horace died in 1897.

43

Willie Stephenson, a local blacksmith in Plainville around 1900, was one of a few blacksmiths in town. His shop was located on the corner of Whiting and Hamlin Streets.

The Plainville Creamery Company was organized in 1887 with Robert Potter, Robert Usher, W. H. Taylor, W. M. Frisibie, and Charles Moore of Southington, James Woodruff of Terryville, and Benjamin Bronson as its directors. The building was located on Norton Place. At the 1894 World's Fair in Chicago, the Plainville Creamery Company entered its butter and won a bronze medal.

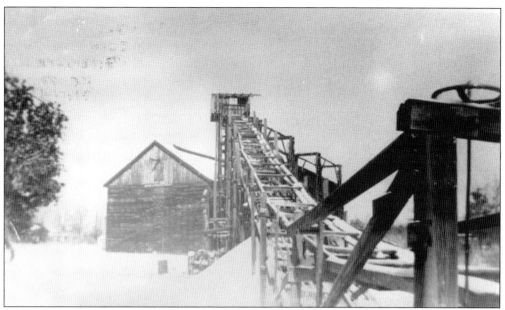

This is the Norton Ice Company icehouse and conveyor around 1840. The business was located off New Britain Avenue. It got its ice from its own ponds.

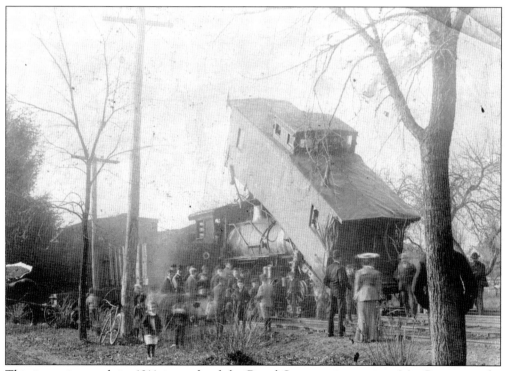

This ice-train wreck in 1911 is south of the Broad Street train crossing. Mr. Corcoteau, the station agent, and his wife are standing on the right. The train was going to New York City when the accident happened.

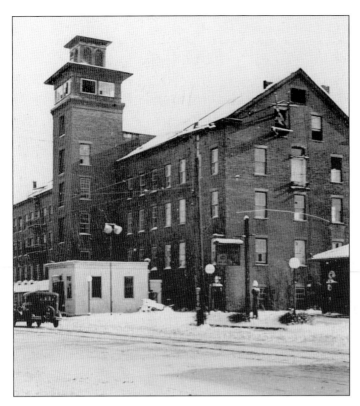

The Plainville Knitting Mill opened on Main Street (West Main Street) in 1850. It was started by Jared Goodrich, who also started the Bristol Manufacturing Company in Bristol and the New Britain Knitting Mill in New Britain. All of these factories made knit underwear and cotton, wool, and silk goods. John F. Chantrell and Benjamin Pollard were tradesmen in England and were brought here to take charge of the Plainville mill. The mill closed in the 1930s. All that remains today is one building that is occupied by Nutmeg Public Access Television, the Plainville Chamber of Commerce, and doctors' offices.

In this picture is a group of women employed at the Plainville Knitting Mill sitting in front of the finishing building around 1920.

Norris Clark came from Bristol in 1840 and began manufacturing clock keys. He formed a partnership with his son Allison N. Clark and son-in-law William A. Carter. The new company formed was Clark, Cowles and Company. Later it became A. N. Clark and Sons. In the upper left corner is Emory Dwight Rogers.

Emory Dwight Rogers was born on May 3, 1842, in Tolland. He married Lucy Oldershaw on September 21, 1867. They came to Plainville in 1881 and lived on Welch Street. Emory worked at A. N. Clark company. He was a member of Franklin Lodge Ancient Free and Accepted Masons (AF&AM). He and Lucy had three children: Myron Emory, Minnie Jane, and Alice Louise. Emory died on March 10, 1896, and Lucy died on October 31, 1925.

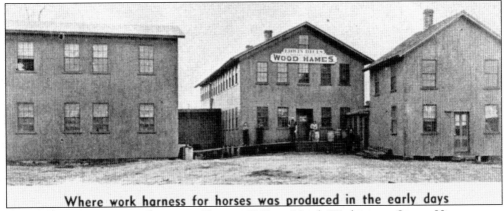

Where work harness for horses was produced in the early days

Hiram Hills started the Hills Hames Shop in 1862 on North Washington Street. His two sons Burritt and Edwin were given an interest in the business. The business grew with the addition of a sash and blind shop, grist- and sawmills, and a quarry. In 1874, Hiram sold his hame business to his sons and his son-in-law L. C. Strickland. The new company was called Hills Brothers and Company. Edwin and Wallace Hills bought all the property south of the Pequabuck River in 1875, and Burritt and his sister Adelaide Strickland bought all the property north of the Pequabuck River the same year.

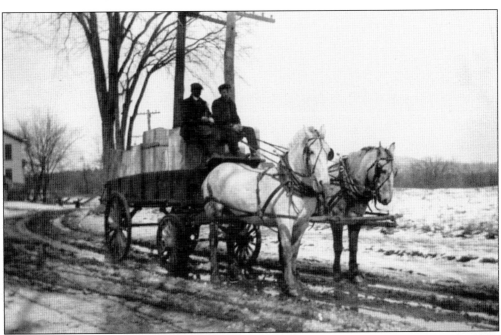

Shown is Edwin Hills's team of horses with some of his products on a wagon from the Hills Hames Shop.

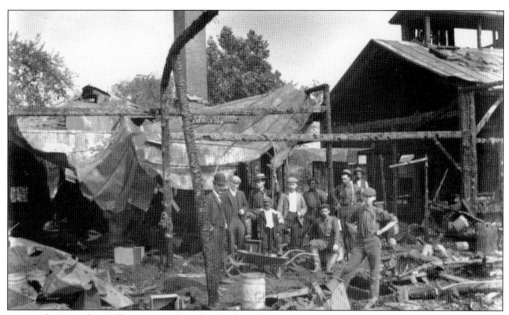

In April 1880, the Hills Hames Shop had a fire that destroyed the wood building. It was replaced with a new brick building.

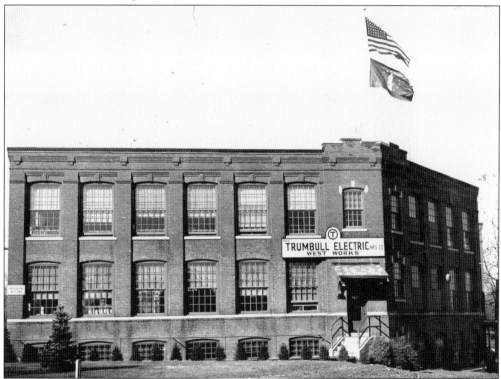

Originally this was Edwin H. Hills's factory, located on North Washington Street, that manufactured hame and hardware sold in department stores along with mail order. The building was purchased by Trumbull Electric Manufacturing Company in 1940 from Emma Hills. This became the West Works plant. The building still stands today.

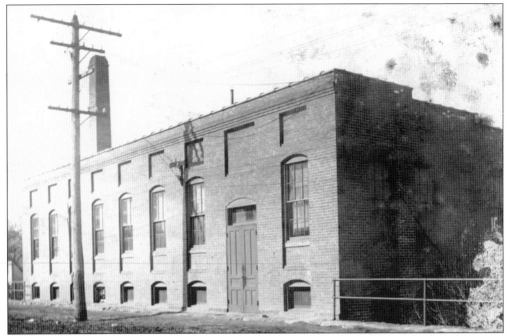

This factory was known as the Osborne and Stephenson Manufacturing Company located on 125 West Main Street. It was originally started by Frederick G. Stephenson behind his house on Whiting Street. The brick building was constructed in 1902. The factory manufactured screw machine products, flexible tubing, automobile horns, and bicycle accessories. The company later passed to Charles V. Norton, who renamed it the Newton Manufacturing Company. The building is now used as a dance studio.

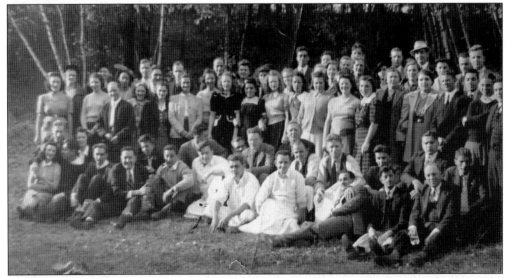

The Peck Spring Company was organized in 1915 by D. C. Peck and his two sons, D. K. and P. L. Peck. D. C. was in the hardware business, and his sons were spring makers by trade. In 1920, they formed this new company called Peck Spring Incorporated. The factory is still located in the old Gridley Garage and Trucking business, along with other buildings next to the original factory. This picture is of an employee picnic taken in 1941.

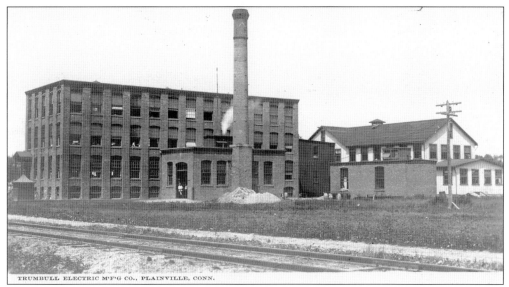

Trumbull Electric Manufacturing Company was started on October 15, 1899, by brothers John Harper and Henry H. Trumbull and Frank Wheeler. John developed the selling and commercial side of the business. Henry became production manager, and Frank designed and developed the tool and die equipment. In the picture, the building on the right is the old chuck shop where Trumbull Electric started. By 1905, the brick building on the left was added. It was followed by additions in 1907, 1917, 1921, and 1930; enlargement of the factory continued with a new office building. In 1918, Trumbull Electric joined with General Electric. General Electric is still in these buildings and plays an important part in Plainville today.

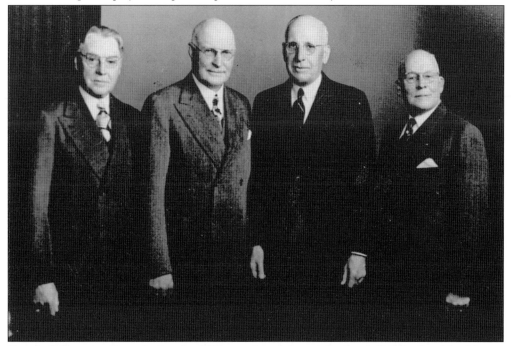

Trumbull Electric officers during the 1920s are, from left to right, Frank T. Wheeler, John Harper Trumbull, Henry S. Trumbull, and Stanley S. Gwillim.

51

Frank S. Trumbull, brother of John and Henry, worked at his brothers' firm Trumbull Electric Manufacturing Company, manufacturers of electric starting motors and other electrical equipment. He then worked at Connecticut Electric Company, which produced the Trumbull Car. He accepted and then became president of the Manchester Silver Company of Providence, Rhode Island. He died on September 27, 1954, at the age of 77.

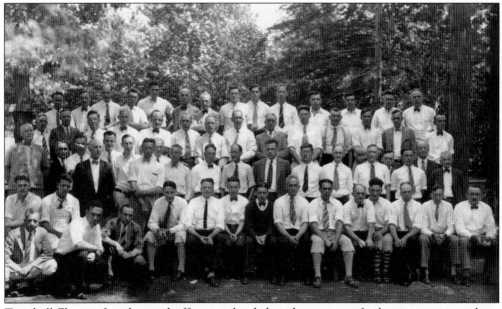

Trumbull Electric founders and officers realized that the success of a business starts with its employees. Trumbull started a bowling club, a factory paper called *Inside the Circle*, a free clinic, and nursing care. In this picture is the sixth annual outing of the Trumbull Modern Production Club at Gehrman's Grove in Meriden on June 21, 1930.

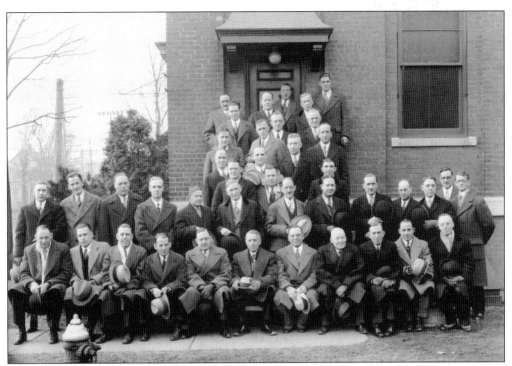

In this picture is a group of men who attended a sales conference at Trumbull Electric that took place from December 30, 1929, to January 3, 1930.

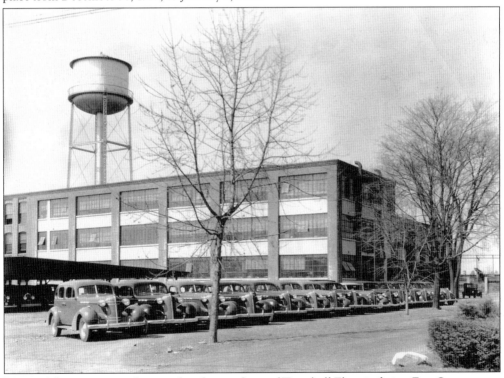

Many of the same type of car are lined up in front of Trumbull Electric facing East Street.

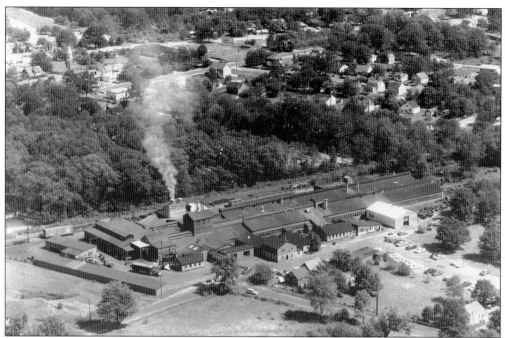

Plainville Casting Company was started in 1921 by H. Stevenson Washburn's grandfather. It was located on the end of Canal Street covering 15 acres of land. The gray iron castings made were used in most products that were manufactured. The plant closed in 1986. Plainville Food Pantry, Gil's Drywall, Nobby Beverage, and Eagle Fence are some of the businesses that are now where the factory was.

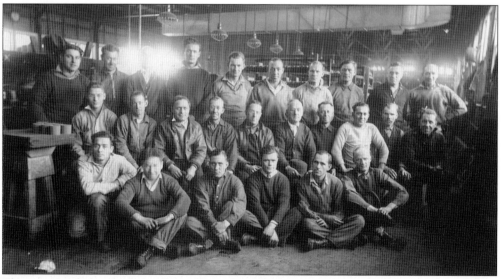

These are employees from the Plainville Casting Company core room in 1938. From left to right are (first row) Archie Larochelle, Joe Palmeiri, Emil Pomerou, Chester Preleski, Nick Colletto, and Carl Mattson; (second row) Herold Williams, Joe Reed, Joe Deyulio, Shane Malley, Lucien St. Onge, Charley Momelou, Enos Schissler, Joe Seglerski, Alec ?, and Oswald Schubert; (third row) Stanley Karasefski, Joe Stephanek, Frenchie ?, Henry ?, Frank Kawaleski, Eric Schubert, Alfred Futterlieb, Theodore Preleski, Albert Williams, and Stanley Ploski.

Four
BUSINESS

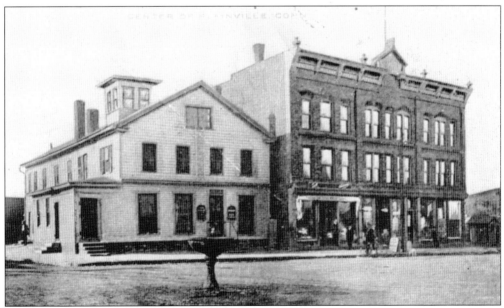

In 1831, Ebenezer Hawley Whiting and his brother Adna built the wooden building on the left. It was a general store that included drugs and medicine. The brick building on the right was built by Thomas G. Russell in 1895. This area became known as Central Square.

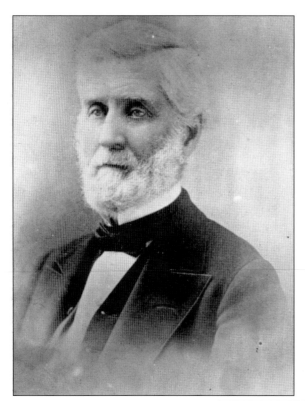

Harmanus M. Welch, son of George Welch of Bristol, came to Plainville in 1835 and started a business near the Farmington Canal called the H. M. Welch and Company. His brother Elisha N. Welch owned the E. N. Welch Manufacturing Company, maker of clocks, in Forestville. H. M. Welch and Company prospered with goods, including clocks from his brother's clock company, delivered by canal boats. In 1856, their main store became part of the Plainville Knitting Mill and the other part became Newton's Dry Goods.

Henry M. Welch, brother of Harmanus and Elisha, lived on Washington Street and operated a large farm. He later went to New Haven to work at the Coal, Lumber and New Haven Clock Company. He became involved with city politics and became mayor of New Haven.

The Plainville Lumber and Coal Company, started by Harmanus M. Welch in 1831, was first located on Farmington Avenue. Then it was located where the Plainville Knitting Mill was. The final move was to 26–28 Pierce Street. It was operated by Harmanus M. Welch and James E. English until 1856, when Edward Noble Pierce purchased the business. The business changed ownership through the years until a second fire in 1980 destroyed the buildings. Today there are condominiums in its place.

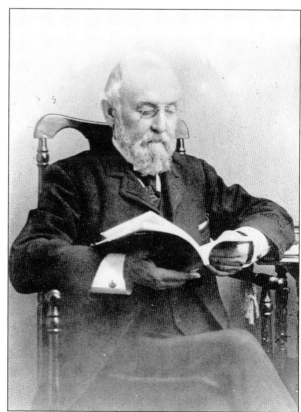

Edward Noble Pierce, son of Noble Pierce of Bristol, came to Plainville in 1847. He first married Henrietta L. Thomson of Bristol. They had one daughter. He then married Pamela F. Thomson, sister of Henrietta. They had seven children.

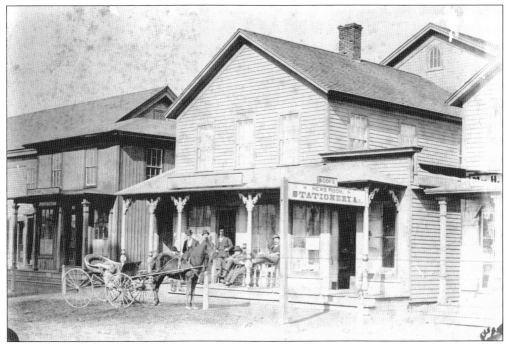

In this 1873 picture, various businesses stand on West Main Street. On the left is the old Newton building owned by William Newton. Tomlinson's Drug Store and the post office are followed by Morgan's Hall, owned by George Morgan, and Marshall Ryder's first store. In 1882, a fire destroyed all of these businesses. They would be replaced later with brick buildings.

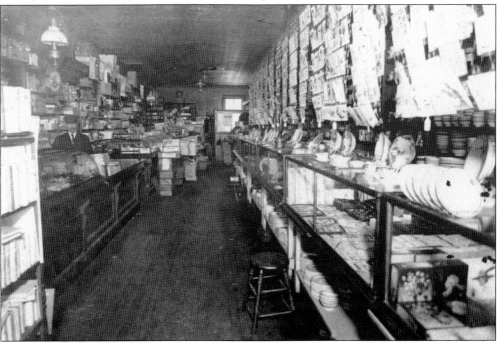

George L. Newton's dry goods store sold oil cloth, paper hangers, boots, shoes, and household goods. It was located on Main Street. This is an interior picture of the products he sold around 1882.

Daniel W. Fox and his wife, Mary Cook Fox, purchased a funeral business from Calvin Johnson on November 4, 1884. He obtained a note for $100 from Bristol Savings Bank and paid $8 in cash for the transaction. Before 1900, a regular funeral was $21, and a fancy one was $41. Daniel and Mary had two daughters, Charlotte F. Diggle and Anna W. Sheffield.

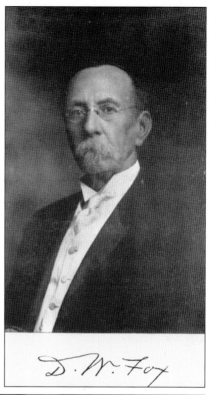

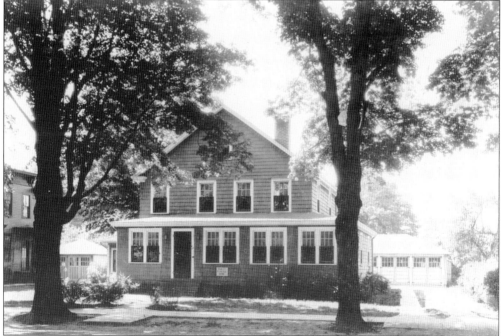

Bailey's Funeral Home at 48 Broad Street is shown before changes were made to the building. This is the oldest family business, celebrating 124 years, in Plainville, with Jim Bailey being a fifth-generation descendant of the Bailey family.

Walter Allen Bailey Sr. and his wife, Anna S. Diggle Bailey, continued the funeral business. Walter had one son, Walter Allen Bailey Jr., who was known as "Bob" Bailey. Bob had two sons, Bill and Jim. Walter was a member of Frederick Lodge No. 14, AF&AM, and Eastern Star Frederica Chapter in Plainville.

Anna S. Diggle Bailey, granddaughter of Daniel and Mary Cooke Fox, became Connecticut's first licensed woman funeral director. She was a member of Eastern Star Frederica Chapter in Plainville.

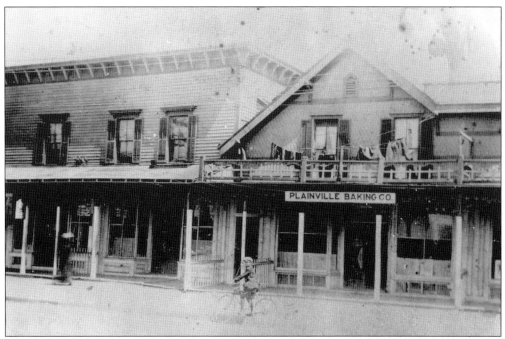

Plainville Baking Company, located on Whiting Street, was started by Myron Emory Rogers on October 12, 1899, when he was 23 years old. He formed a partnership with John E. Lamb, his brother-in-law. Rogers later bought out Lamb's share of the business. The business stayed here until 1918.

Myron Emory Rogers was the son of Emory Dwight Rogers and Lucy Oldershaw Rogers. Myron married Olive Madelay on October 20, 1897. They had one daughter, Mildred. Myron married Idella Manchester from Bristol after his first wife died. Myron and Idella had seven children: Mildred Elinor, Dorothy Adelia, Myron Leigh, Melvin Emory, Howard William, Lucy Manchester, and Beatrice Jennie. Besides working in the bakery, Myron served as a state representative. He was a member of Frederick Lodge No. 14, AF&AM. Myron continued working at the bakery until he died on October 22, 1958, at the age of 82. Idella died on October 18, 1939.

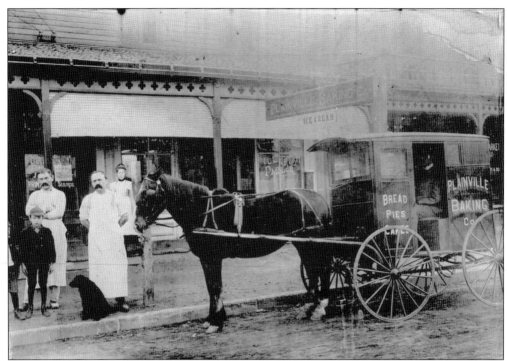

Along with the Plainville Baking Company store, Myron Rogers had a wagon to deliver fresh baked goods both in town and to surrounding ones. Deliveries went all year round. There were as many as seven wagons at one time. In this picture, Myron is on the left next to his horse and wagon.

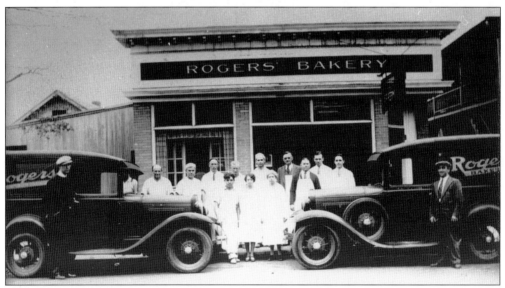

When the Plainville Baking Company had a fire in 1918, the business moved across the street into its new building and changed the name to Rogers Bakery. Myron's son Melvin took over the business along with his two sons Melvin and Donald Rogers. When the business closed on October 8, 2005, it was owned by Melvin's children Ken and Laura Rogers, who were fourth-generation descendants of Myron Rogers.

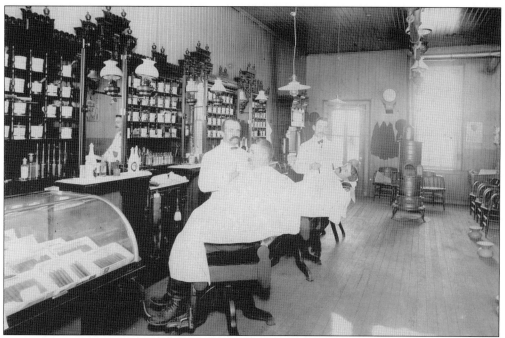

Balsar Fait, born in 1842 in Germany, came to the United States at 18 years old. He worked in New York learning the trade of a barber. He came to Plainville in 1860 and opened a shop on Main Street. Note the personal shaving mugs on the shelves for the regular customers who came to the shop. Balsar died on August 5, 1897, leaving a wife and two children.

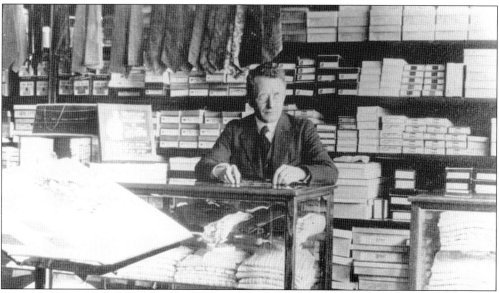

H. Garfield Jones started a men's clothing store in 1915. His son Fremont purchased a block of eight stores that included some on Whiting and West Main Streets and his father's store. When H. Garfield retired in 1948, Fremont took over the business. A women's department was added in 1959. Kirk Jones, son of Fremont, joined the business in 1975, custom outfitting men with suits, ties, shoes, and formal wear. In 1996, the store closed after 85 years in business. Today an insurance company, along with other retail stores, takes it place.

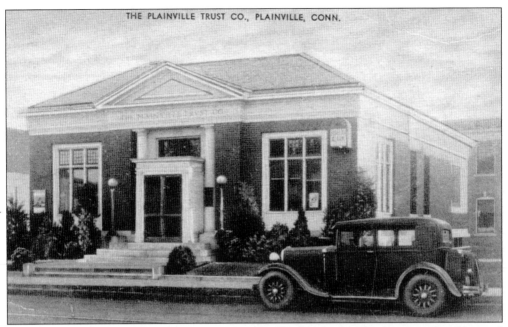

The Plainville Bank and Trust Company was originally chartered under the name First National Bank in 1909. The bank, located on the corner of West Main and Pierce Streets, was started by Gov. John Harper Trumbull in 1908. In 1915, the bank became a State of Connecticut bank and changed its name to Plainville Bank and Trust. A pet store is now in this building.

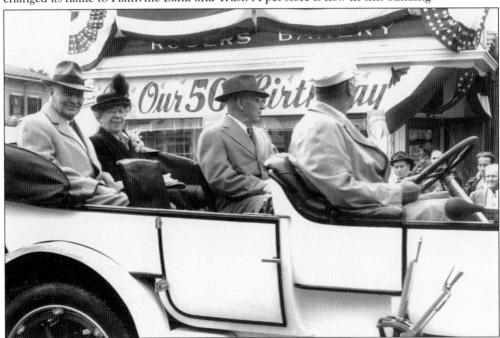

On October 15, 1949, Trumbull Electric Manufacturing Company and Rogers Bakery were both celebrating 50 years of being in business, with a parade honoring both of them. In the back are Gov. John Harper Trumbull and his wife, Maude. In the middle is Henry Trumbull, brother of John.

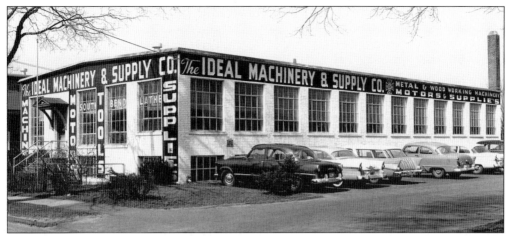

Ideal Machinery and Supply Company was originally known as Ideal Switch and Machinery Company. The business was started by Frederick and Barbara Evans Heorle and was incorporated on December 28, 1906. The company made electrical switches, spark plugs, and automobile supplies. Frederick Heorle was president and treasurer and Clayton J. Foster was secretary. When the business was reorganized in 1915, it moved from West Main Street to its present location at 109 East Main Street. Roland Evans Heorle, Frederick's son, worked with his father in the business. When Frederick died in 1925, Roland took over the business. Roland had two sons, Cadwell "Caddy" and Fred. Caddy joined the business in 1945, and Fred joined in 1950. Roland died in 1954, leaving his two sons with the business. When Fred died in 1991, the business was owned and operated by Caddy. His two sons Theodore and Arthur and his daughter Signe Heorle Guzzo joined the business in the 1980s.

In this 1969 picture, taken during the centennial celebration of Plainville, are Fred and Caddy Heorle. They are the grandsons of Frederick and Barbara Evans Heorle, who in 1906 started Ideal Switch and Machinery, which later became Ideal Machinery and Supply.

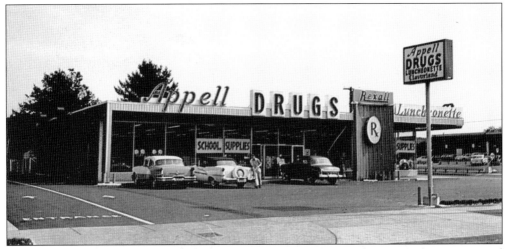

Harry Appell went to the College of Pharmacy in New Haven and upon graduation married Ada Katz in 1935. They came to Plainville to live. In 1936, Harry purchased a store at 2 East Main Street. He started Plainville Pharmacy and built a building on East Main Street. In 1958, the business moved to 52 East Street and changed the name to Appell Drugs. He added the luncheonette in 1959 and closed it in 1966. His son J. Kemler Appell joined the business in 1959. Harry was active in the community, serving as president of the chamber of commerce in 1953–1954 and serving on the town council from 1959 to 1967. Harry's son Kemler opened a store in New Britain with a pharmacist in 1969. It was sold to the pharmacist as a franchise. Arrow Drug became the new business name.

In June 1905, John C. Twining of Waterbury purchased two tracts of land. These building lots were known as South Side Park and South Side Park Annex. That same year Charles H., Edward, and Henry Hanson, operating under the name of Hanson Brothers, bought the land and constructed this building. The business manufactured screws, nuts, and machinery. Charles bought out his brothers and in 1910 and 1915 enlarged the building. In 1925, the Cedar Hill Formulea became the next business in the building. They were a polish manufacturer for silver and furniture. In 1962, Edward Archambrault purchased the building for his company, Connecticut Homeward Step Company. The name changed with the next owner in 1979 to Connecticut Precast, makers of cement blocks. In 1984, Chester and Lynda J. Russell purchased the building for their business that started in 1977 as the Window Shop Inc.

Five

TRANSPORTATION

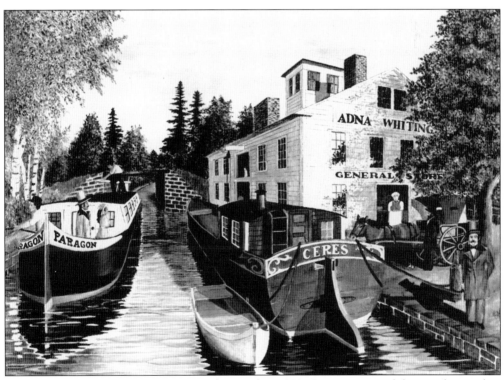

The Farmington Canal Company was chartered in 1822. Construction of the canal started in 1825 and opened in 1828. Brothers Adna and Ebenezer Whiting bought land in 1828 at the junction of East Main Street and Farmington Avenue, dug a basin where canal boats could dock, and built a general store. It was known as Whiting's Basin. In 1830, they sold the land and buildings to Timothy Cowles. They built another basin and store from land that Adna purchased from Asahel Hooker. A dock was built alongside the building so canal boats could pick up or deliver goods. This basin was known as Bristol Basin. This painting by Dr. L. H. Frost shows Bristol Basin with West Main Street crossing on the bridge in the 1830s.

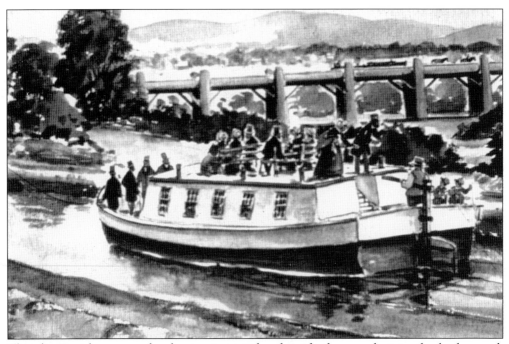

This drawing shows a packet boat going to church with the aqueduct in the background. Churchgoers paid 3¢ for the ride, which took one hour each way.

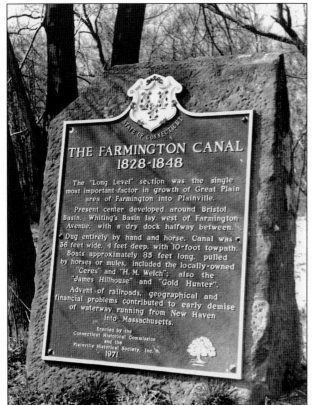

This dedication to the Farmington Canal and restoration was erected by the Connecticut Historical Commission and the Plainville Historical Society in 1971. It was placed in Norton Park near part of the canal that is still preserved.

Josiah John Russell, born in 1805, came from Cheshire to Plainville in 1839. He married Eliza Ann Brockett of Southington and built their home at 107 South Washington Street next to the Farmington Canal. Josiah worked on the canal boats. They had nine children. Josiah died in 1880 and Eliza in 1895.

Andrew Norton, son of Parrish and Betsey Royce Norton, was born in 1813 at Compounce in Southington. He had three brothers and a sister. He first married Miranda Byington and then Laura E. Spelman. He had two children. He was the captain on the boat *Ceres*, owned by Adna Whiting. Goods like sugar, molasses, salt, coffee, flour, apples, butter, and wood would be transported. The *Ceres* was 75 feet long, 8 feet wide, and 4 feet deep. A crew of four could sleep in it. When the canal closed, Andrew worked at the Plainville Knitting Mill. Andrew died in 1897 at the age of 84.

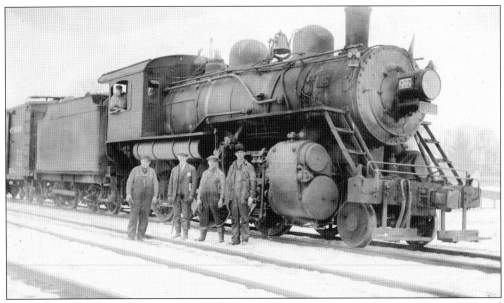

Due to washouts from the poor soil and the resulting expensive repairs, the Farmington Canal did not prove to be a financial success. In 1846, the stock of the canal company passed to the control of New York parties who formed a charter for a steam railroad to operate from New Haven to Northampton, Massachusetts. The freight train No. 272 of the New York, New Haven and Hartford Railroad is shown here in Plainville around 1924.

On the left is Samuel Bentley, who came to Plainville on January 11, 1848. He was the first conductor in charge of the first passenger train.

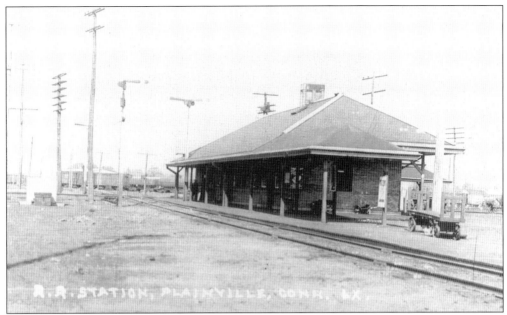

With the completion of the New Haven and Northampton Railroad through Plainville, the first train depot was built in 1848. It stood at the lower end of the Bristol Basin on West Main Street. It was moved across the street in 1850 to accommodate the new Boston, Erie, and New England Railroad. The above depot was the third one built, in brick in 1901. It was torn down around 1980. The Plainville Municipal Center stands in its place.

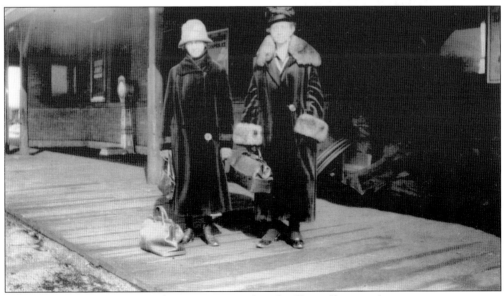

In this 1926 picture, two traveling women stand at the Plainville train depot.

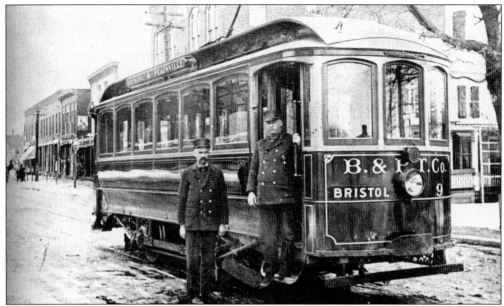

The trolley system was started in 1893. In 1895, the Bristol and Plainville Tramway Company was formed. Opening up the line to Bristol and extending it to Southington, Charles S. Treadway and John Humphrey Sessions, both of Bristol, were among the chief backers of the company. There was also a short line trolley that went into Farmington. This picture, taken around 1916, is of West Main Street. The trolleys ended in 1936, with the last trolley service to New Britain.

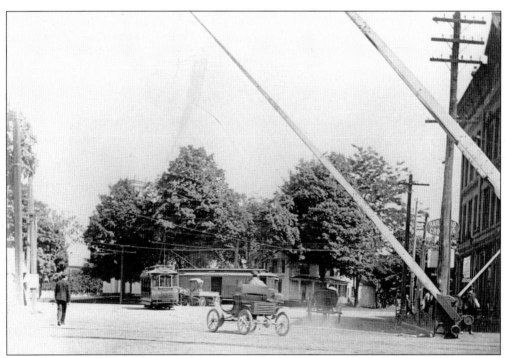

This early-1900s picture is of a car at the intersection of West Main and Whiting Streets. On the right is the Russell Block with a horse and buggy traveling in front of it.

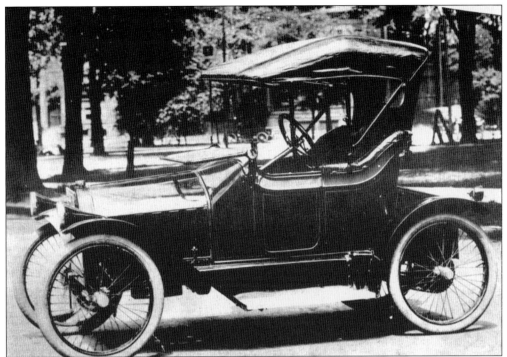

The Trumbull Motor Car was built in Bridgeport from 1913 to 1915 by a company known originally as the American Cycle Car Company, whose name was changed in 1913 to Trumbull Motor Car Company. It was manufactured by two brothers, Alexander Hugh and Isaac Blair Trumbull. They were two of the seven brothers of John Harper Trumbull of Trumbull Electric Manufacturing Company. The cost of a roadster was $425 and $600 for the coupe. The standard color was black with a nickel trim, but for an additional $15 one could have a different color.

The John Cellino filling station was located on the corner of Newton and Whiting Streets. In this 1933 picture from left to right are John Cellino, his son Peter, and Anthony Guerriere.

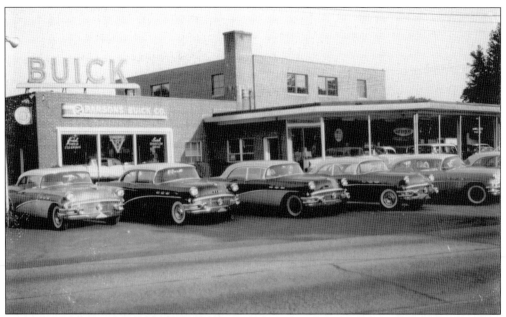

Stanley T. Parsons started the Parsons Buick Dealership in Plainville on September 23, 1948, first in temporary quarters at 127 Whiting Street. It operated with John Cellino's service station while waiting for its new building at 151 East Street to be built. The main building was completed in 1949, and the saleroom was added in 1953. When the company started in 1948, they had two employees. Today the business continues with Stanley's sons Stephen and John Parsons.

Stanley T. Parsons

Stanley T. Parsons was the son of Lt. Gov. Robert E. Parson of Unionville. He was general manager of the Robert E. Parsons Buick dealership in Farmington when he was appointed a new dealership in the town of Plainville.

This early picture is of Anthony's Service Center when it was a gas station with two garages for service. Anthony Guerriere bought the building in 1946. Today the business, located on 136 East Main Street, is continued by his son Robert.

Nels J. Nelson was born in Sweden on January 2, 1886. His family immigrated to the United States and settled in New York when he was a young boy. He came to New Britain around 1909 and worked as an apprentice toolmaker at Stanley Rule and Level Company. He became interested in flying after Orville Wright and others began flying. He and his friend Frank Rund constructed a biplane glider. He would later build airplanes and do exhibitions in various locations. In this picture, taken in 1913, on the left is Rund, and Nelson on the right. Nelson died in 1964 at the age of 78.

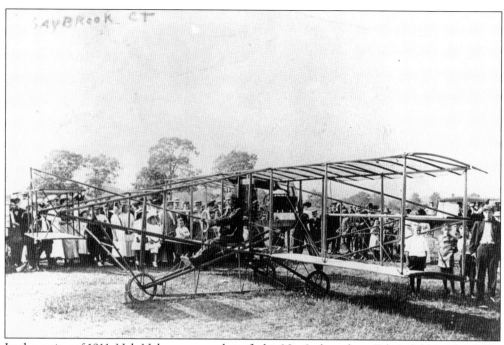

In the spring of 1911, Nels Nelson was ready to fly his No. 2 plane from Tyler's field in Plainville. It became his first successful flight. In this picture taken in 1911, Nelson is flying his No. 3 plane in Saybrook.

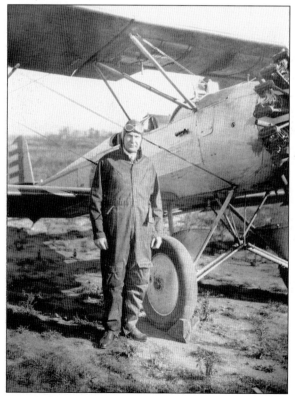

John Harper Trumbull, known as the "Flying Governor," first became interested in flying in 1924 at the age of 51. He obtained his pilot's license in 1927. His daughter Jean liked to fly with him. Trumbull served on the Aeronautics Commission for the state of Connecticut.

Six
Those Special People

Charles Hotchkiss Norton was born in 1851 to Harriet Hotchkiss Norton. He grew up in Plainville on the corner of East Main Street and Norton Place. He left Plainville to work in a clock factory. He then became a design engineer with Brown and Sharpe Manufacturing. He started his own company in Worchester, Massachusetts. When he retired he came back to Plainville and built a home on Red Stone Hill and gave 69.9 acres of land with his daughter Elizabeth Harding Norton to the Town of Plainville for a park known as Norton Park on August 8, 1928.

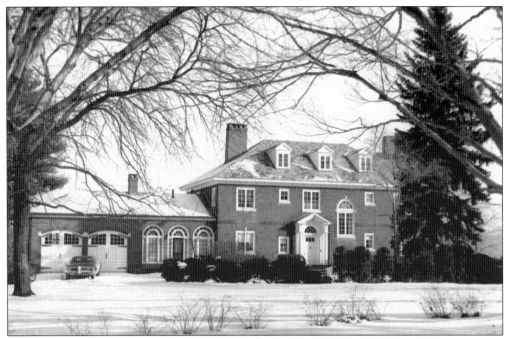

This home, known as Sharpenhoe, was built by Charles Hotchkiss Norton in 1922. He purchased the land from Edward Noble Pierce's estate in 1917. Upon his retirement in 1922, he lived here with this family. This home on 132 Red Stone Hill was once the farmland of the Thomas Lowrey, Hooker, and Curtis families. The home remains a private residence today.

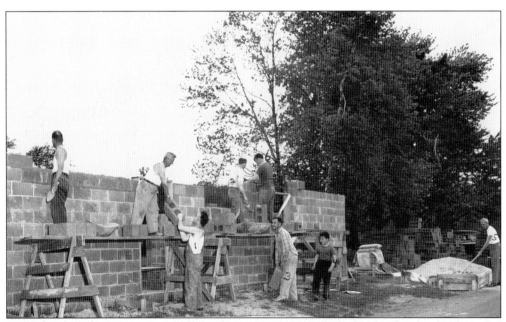

The development of Norton Park was slow due to a lack of funds. The Plainville Lions Club decided to make the park its project in 1946, raising $15,000. In this picture, dated 1949, the following club members are building the bathhouse. On the ground from left to right are Bill Tolli, Bob Onorato, David Tolli, and Eddie Munn. In the back row second from left is A. Westergren.

Henry Allen Castle, born April 18, 1869, in Plainville, was the son of Samuel B. and Jane C. Castle. Henry went to Broad Street School. In 1888, he was employed as a bookkeeper for Brown and Gross, a publishing company. In 1896, he was employed by the Pope Manufacturing Company in Hartford. He married Mary C. Hadsell of Plainville in 1895. They had one daughter, Gertrude. In 1916, Henry worked for Trumbull Electric Manufacturing Company as a purchasing agent. He served the town of Plainville on various boards. He was the town historian. He wrote histories for many of the churches, but none were ever published. He also wrote the *History of Plainville*. He was a member of Frederick Lodge. He died on August 8, 1960.

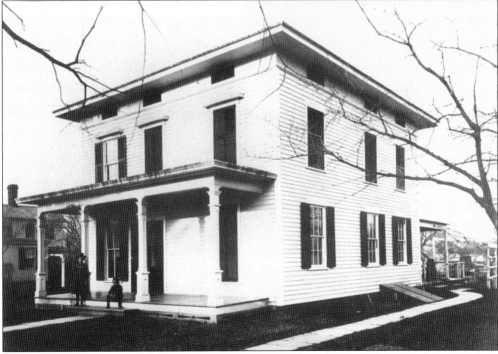

This was the home of Henry Allen Castle at 14 Canal Street. Originally the Episcopal Church purchased the land and house in 1865 for the rector of the church to live in before Castle lived in it.

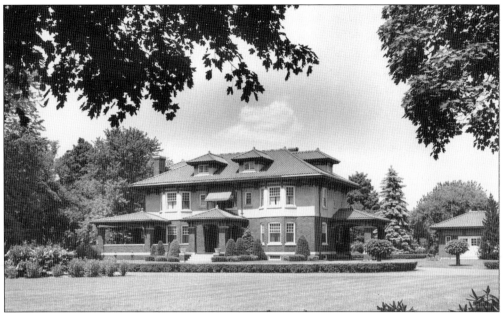

Henry Trumbull was born in Plainville on January 12, 1875, to Hugh and Mary Trumbull. Henry went to Plainville schools. His first job was at Eddy Electric in Windsor as an apprentice learning the trade. In 1899, he and his brother John started Trumbull Electric Manufacturing Company. Henry first married Nettie Northrop in 1903. They had one daughter, Esther Trumbull. He then married Florence White. He was a member of the Plainville Chamber of Commerce. This home at 14 Farmington Avenue, built in 1912, was torn down in 1964. Henry died in 1962.

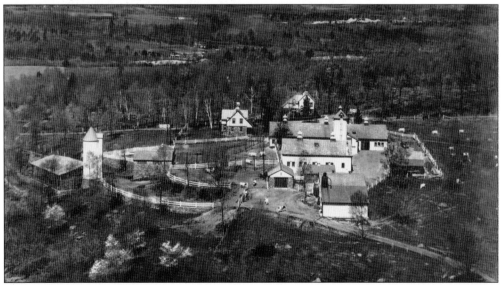

Henry Trumbull purchased 100 acres of land in 1919 near Pinnacle Mountain. He developed it into a dairy farm called Pinnaclerox Farm. It grew to 280 acres, producing milk from 100 purebred Ayrshires. He operated the farm from 1920 to 1953. The farm also grew vegetables and potatoes, and when there was extra these items would be donated to the needy families in town. Henry sold the farm in 1956. Once the livestock were sold, the land was developed for housing, with 130 acres in Plainville and 190 acres in Farmington.

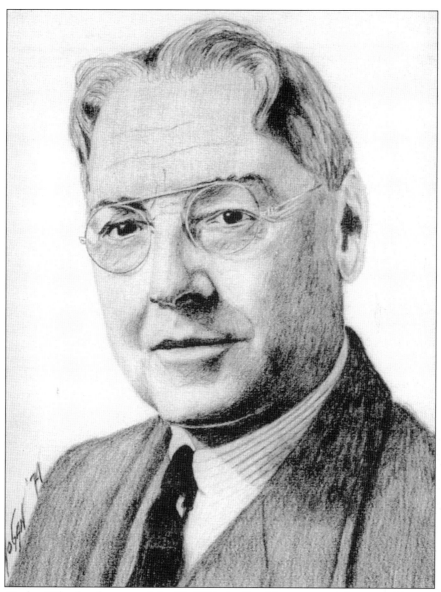

Frank Taylor Wheeler, born on July 23, 1874, in Southington, was the son of James Frank and Sarah Ann Taylor Wheeler. He attended local schools in Southington, graduating from Lewis High School in 1892. He apprenticed at Southington Hardware Company, learning the trades of machinist and die casting. In 1899, he joined John and Henry Trumbull in starting Trumbull Electric, starting as president and then vice president until he retired in 1945. He married Bertha M. Buell from Southington on June 20, 1903. They had no children. They built a home at 29 Farmington Avenue in Plainville. Frank served as vice president of Plainville Trust Company. He helped organize the Plainville Chamber of Commerce and served on the town planning commission. He was a member and past master of Franklin Lodge No. 14, AF&AM, and belonged to other organizations. When he died in 1950 at the age of 76, he left a trust fund of over $1 million, making the Town of Plainville his beneficiary. On August 20, 1951, the Plainville School Board named the new elementary school on Cleveland Memorial Drive the Frank T. Wheeler School.

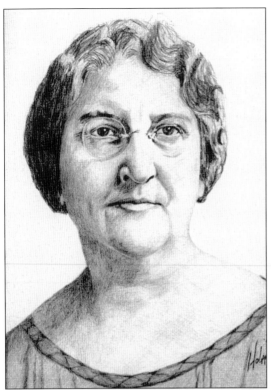

Bertha M. Buell Wheeler was born in Southington on February 25, 1873. After her marriage to Frank Wheeler, she became active in volunteer work during World War I and World War II. She and her husband help establish the building of the Plainville Public Library. She was active in the Public Nurse Association. She was an honorary member of the first Girl Scout committee, receiving the Thanks Badge award, which is the highest award given to adults. She died at her home on January 23, 1960, leaving over $4 million to the Town of Plainville.

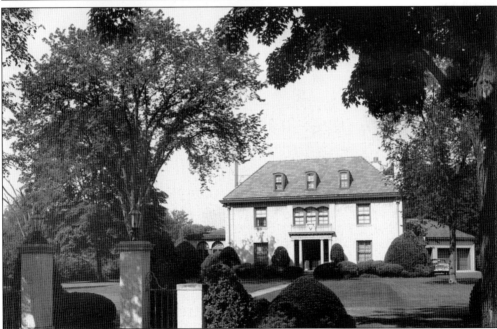

Built in 1926, this was the home of Frank and Bertha Wheeler at 29 Farmington Avenue. When Bertha died in 1960, their home, through their estate, became a YMCA. The home became known as the Plainville Wheeler YMCA Center. The home was torn down on January 4, 1965, to make way for Route 72.

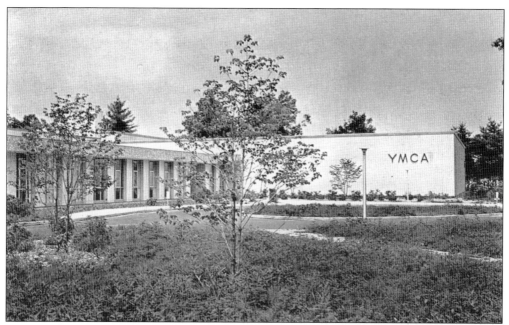

In January 1961, from the endowment of Frank and Bertha Wheeler, 5.7 acres of land were purchased for the new YMCA building on Farmington Avenue. This picture shows the Wheeler YMCA after it opened in 1963.

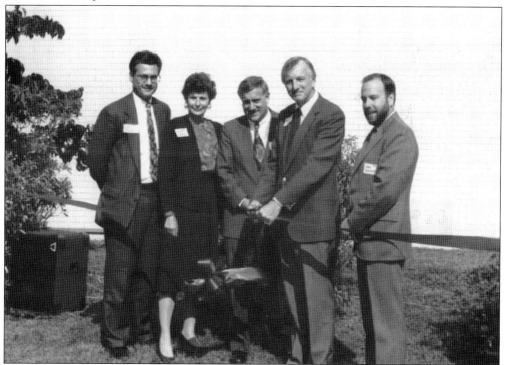

Shown here is the ribbon cutting after a capital campaign for the Wheeler YMCA. From left to right are Ron Bucci, Dorothy Rogers, Robert Festa, Bill Petit, and John Bohenko, town manager for Plainville.

In Bertha Wheeler's will, a trust fund was set up to establish a hospital in Plainville. The Regional Mental Health Council was formed in 1965 to prepare plans for regional mental health services. In 1968, Wheeler Clinic was established, and in 1969, the Wheeler Clinic became trustee for the portion of the Bertha Wheeler bequest of $1,133,014 to start the clinic. The above building, Wheeler Affiliates, opened in 1973 on North West Drive in Plainville. It still serves the needs of the community and other towns in its various programs today.

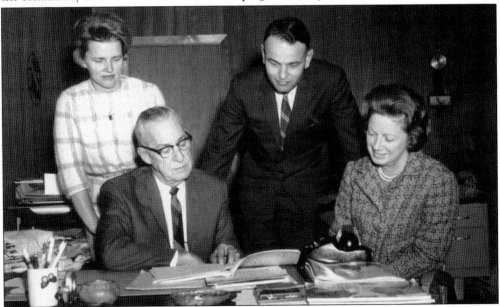

In the above picture are the first officers of Wheeler Clinic on January 8, 1968. They are (standing) Margit Heorle, treasurer, and Paul A. Marier, vice chairman; (sitting) H. Stafford Kellam, chairman, and Mrs. Wallace Barnes, secretary.

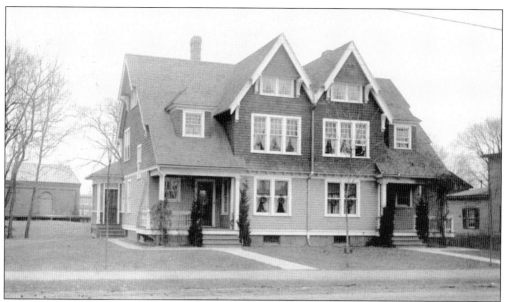

Located at 59 East Main Street, this was the home of Louis Toffolon who came to Plainville in the 1930s with his wife, Florence Welz. Louis was born in 1892 in Pasiano, Italy. His family came to the United States and settled in New Britain in 1903. Louis started working in construction as a water boy in New Haven. In 1935, he started his own construction company called White Oak Excavators, located on West Main Street. The Toffolons had five children: Adele, Ruth, Roger, John, and Norman. Roger and John joined their father's business in the 1940s. Through the years, Louis became involved in various organizations, including the Plainville Community Chest, the YMCA, the Unico Club, and the chamber of commerce. He gave his time and financial support for many town projects. Louis died in September 1966 at the age of 74. In October that year, the new elementary school on North West Drive was named Louis Toffolon School in his honor. The house was torn down in 1999.

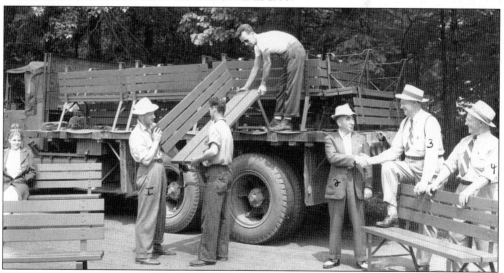

In this picture, some of the Unico Club members are delivering the 20 wooden benches constructed by the club for Norton Park. On the left is John Toffolon, on the right shaking hands is John Tolli, president of Unico; Clyde Ellingwood, park commissioner; and Louis Toffolon.

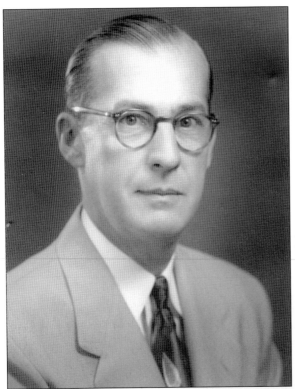

H. Stafford Kellam was born in Shady Side, Virginia, on January 17, 1906. After attending local schools and the Virginia Polytechnic Institute, he left Virginia in 1926 to work at Moorhead Inspection Bureau in Chicago. He married Esther Trumbull, daughter of Henry and Nettie Trumbull in 1931. They had one daughter, Martha. In 1946, he joined Trumbull Electric Manufacturing Company and worked there until he retired in 1967. He was involved locally in the Red Cross and served as director and president of the Plainville Chamber of Commerce. He worked as the first chairman of the Wheeler Clinic, cofounded the Plainville Community Chest, and served on the board of New Britain General Hospital. He joined Frederick Lodge No. 14, AF&AM, in 1935 and became master in 1954. He died on June 9, 1979, at the age of 73.

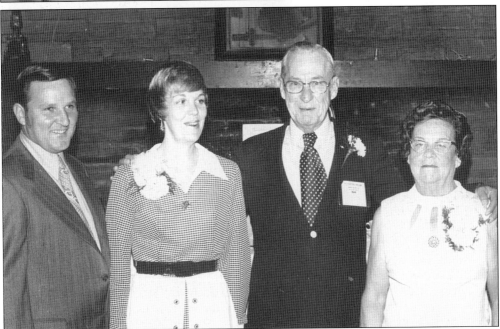

H. Stafford Kellam received the Fred A. Harvey Award on May 22, 1973. This award was given by the Connecticut Association of Purchasing Management, of which Stafford was a member and president in 1954. From left to right are Jim Couture, Martha K. Couture, H. Stafford Kellam, and his wife, Esther Trumbull Kellam.

Seven
SERVING THE PUBLIC

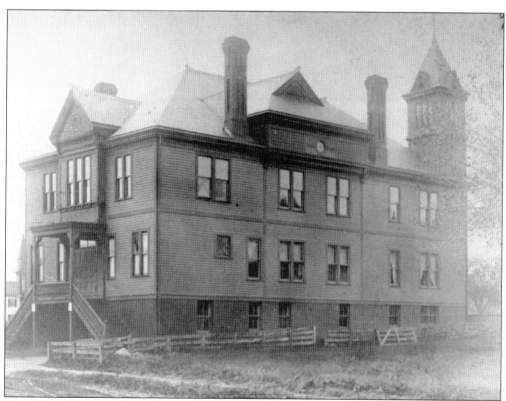

The Plainville town officers first started discussing the building for fire apparatus and town records in 1886. In 1887, Robert A. Potter, Frank S. Neal, and Hiram Carter were chosen to look at land near the old Adna Whiting store, followed by land on East Main Street. Finally, on March 4, 1889, land was purchased at 29 Pierce Street. The basement area was the Plainville Hose Company. The rest of the building was the town hall. The building still owned by the town of Plainville was dedicated on May 30, 1976, as the Plainville Historic Center.

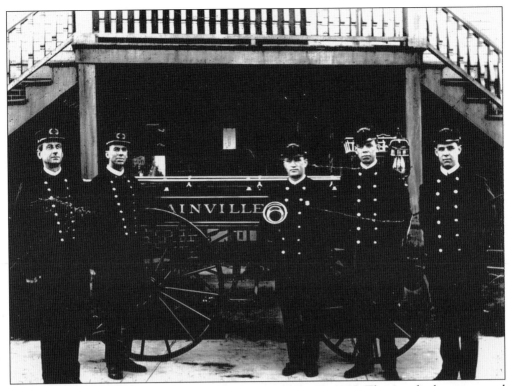

The Plainville Hose Company was organized on January 12, 1885. They used a hose cart and 1,000 feet of hose stored at the Plainville Manufacturing Company until the town hall was built in 1889. They used the basement for storage and used a room in the town hall for meetings.

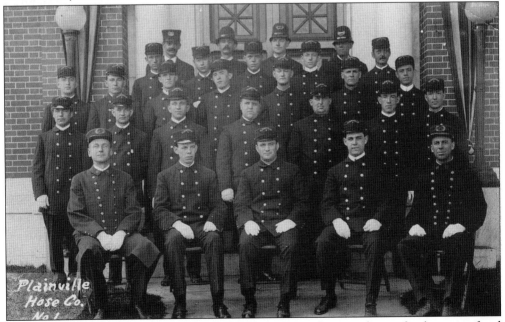

In 1908, the Plainville Fire Department received no pay for attending a fire but were fined 50¢ if they did not go.

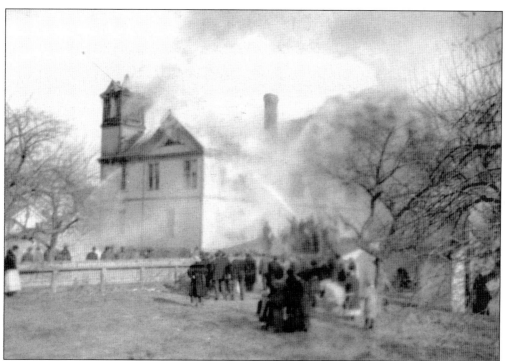

On December 4, 1917, a fire destroyed the third floor and the tower of the Plainville Town Hall. When the building was repaired, the third floor and tower were not replaced. A new roof was built over the second-floor courtroom, and the basement became the new first floor.

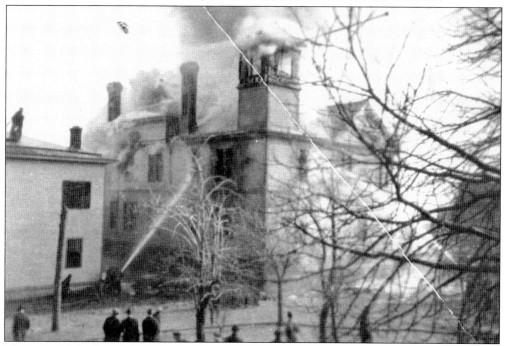

This view of the fire of the Plainville Town Hall shows the Grange hall on the left with the fire department trying to save the building.

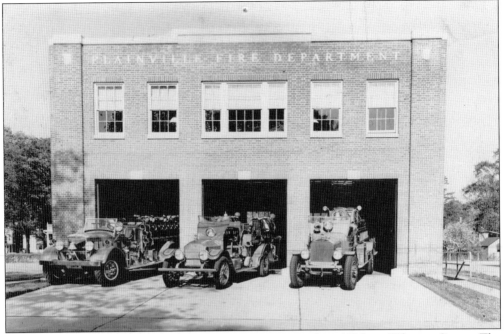

The Plainville Fire Department building was constructed in 1936 on Whiting Street. The brick building was constructed by the Works Progress Administration, an agency whose workers did construction of service buildings such as firehouses and post offices. The new firehouse was built on West Main Street. This building is now used by the Town of Plainville Park and Recreational Department.

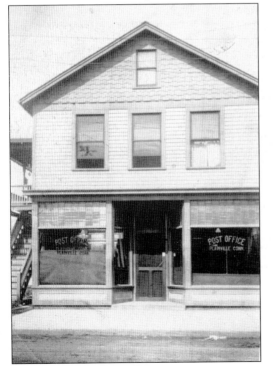

This building, located on 27 Whiting Street, was used as the post office from 1913 to 1934. The building was leased from Myron Rogers, owner of Rogers Bakery. There were many businesses there after the post office constructed a new building across the street. In this place today is Hair Say Beauty Salon.

In 1695, the first highways were laid to the Great Plain and White Oak from Farmington. Early settlers either walked or rode to Farmington to get their mail. Around 1800, Thomas Gridley from the Great Plain was a post rider delivering and carrying letters in his saddlebags. In 1829, a group of men met at Blossoms Corner to discuss the need for a better postal facility. At this meeting, John H. Cooke recommended Dr. Hotchkiss as postmaster. Lemuel Lewis suggested the name Plainville for the town. A petition was circulated in the village and sent to Washington. Washington granted the petition, and Dr. Hotchkiss became the first postmaster in 1830, and the name Plainville became the official name of the town. From 1830 to 1853, the Plainville Post Office was in taverns owned by the postmasters. The post office was built in 1934 with an addition built in 1960. It is located at 60 Whiting Street.

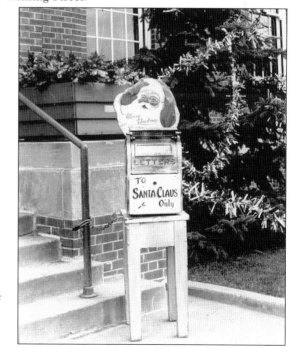

Starting when Andrew J. Sataline was postmaster, followed by Robert Cassidy after 1955, this Santa Claus letter box was put out in front of the Plainville Post Office each year in December. Now there is a larger mailbox that was designed and painted by Sharon Petit Beaulieu, daughter of the late Harry Petit.

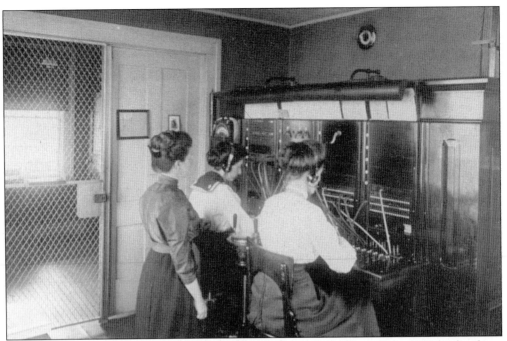

The Plainville exchange started in 1908. Dial telephones came to Plainville in 1953. In the above picture from 1911, the telephone operators are, from left to right, Laura Benidict, supervisor; Miss Violet from New Britain; and Mildred Hart.

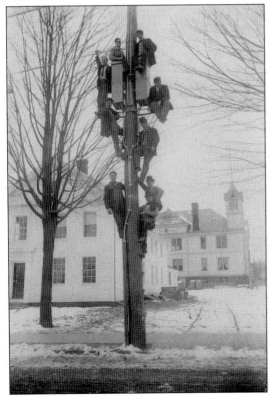

This picture was taken in 1908 during the celebration of the opening of the Plainville Telephone Exchange, with the men hanging the cable line. The house behind them is Hiram Hill's home, which was used by the telephone company until 1969. Behind to the right is Plainville Town Hall prior to the fire of 1917.

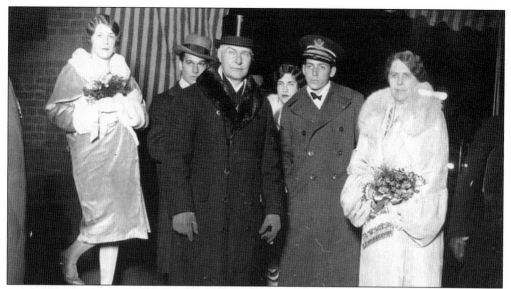

One of the most prominent citizens of Plainville was John Harper Trumbull. He was the oldest of seven sons of Hugh and Mary Trumbull and was born on March 4, 1873, in Ashford. His family came to Plainville in the beginning of the 20th century. He started Trumbull Electric Manufacturing Company with his brother Henry and Frank Wheeler in 1899. He married Maude Usher in 1903. They had two daughters, Florence and Jean. John entered politics in 1921. He was elected in the Connecticut Senate from 1921 to 1925, was elected lieutenant governor in 1924, and became governor in 1925. He was reelected governor two more times, in 1927 and 1931. In this picture, taken in Hartford in 1928, from left to right are Florence Trumbull; a family friend; Gov. John Trumbull; Jean; John Coolidge, who was the son of Pres. Calvin Coolidge; and Maude Trumbull. John retired from his company in 1944, when he sold the company to General Electric. He died on May 21, 1961.

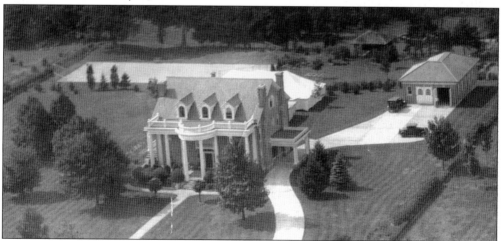

In 1914, John and Maude Trumbull built this home at 39 Farmington Avenue. When John was governor of Connecticut, it was known as the Governor Trumbull mansion. When John and Maude's daughter Florence married John Coolidge, they were married in Plainville and had the reception for 300 guests at the mansion. After Maude Trumbull died in 1963, the mansion was offered to the Town of Plainville for a municipal building, but the town did not want it. The mansion was later town down. Today there are condominiums in its place.

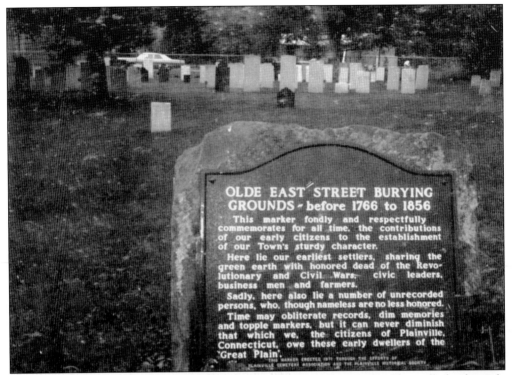

The oldest cemetery located on East Street was the first burying ground in Plainville for the early citizens of the town. In 1856, North Washington Street cemetery opened as West Cemetery. St. Joseph's Cemetery is on Farmington Avenue next to Wheeler YMCA.

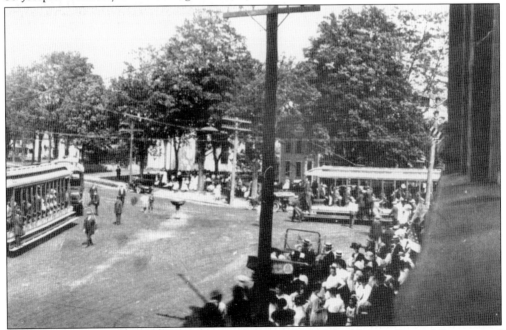

This 1913 picture, taken from the window in the Russell Block building in Central Square, is of the day of the dedication of the Civil War monument.

The Civil War monument was originally in Central Square. When the Veterans Memorial Park was made on Maple Street, the monument was moved here.

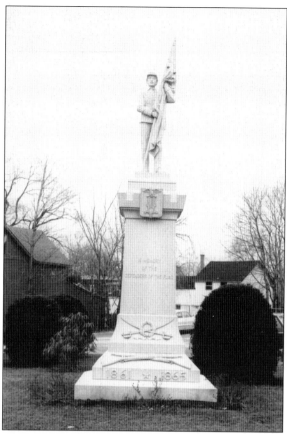

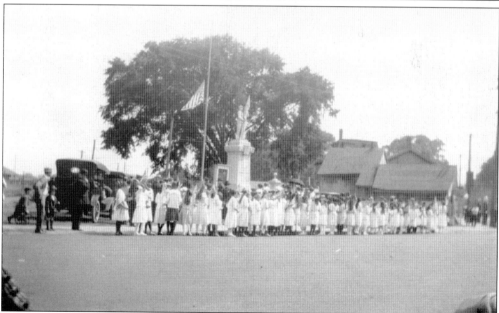

On Memorial Day in 1920, in Central Square next to the Civil War monument, is a group of people during a service remembering those who fought serving their country.

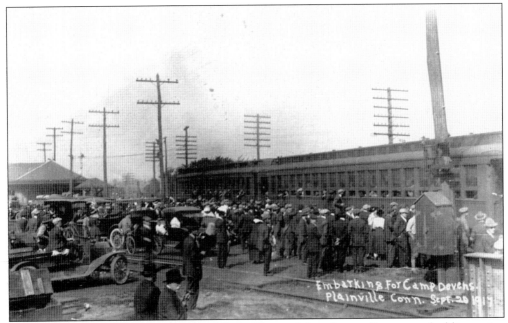

At the train station on September 20, 1917, families and friends see off a group of soldiers going to Camp Devons.

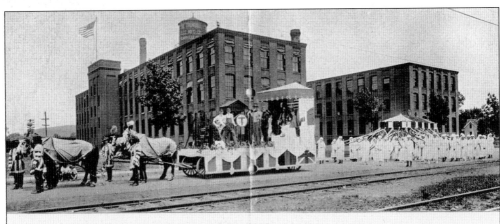

On June 25, 1919, a welcome home parade was given to the returning World War I soldiers. In this picture is the Circle T float and Circle T Red Cross Unit. Trumbull Electric Manufacturing Company employed 93 women in their plant who provided clinical and nursing care for the employees. These women were also a part of the Red Cross Organization and were affiliated with the Plainville Headquarters of the Red Cross.

Old Mastin Homestead July 1, 1930

This is the home of George Mastin. The house was at 56 East Main Street and was torn down to build the library. Mastin donated the land and established a trust fund to purchase books for the library.

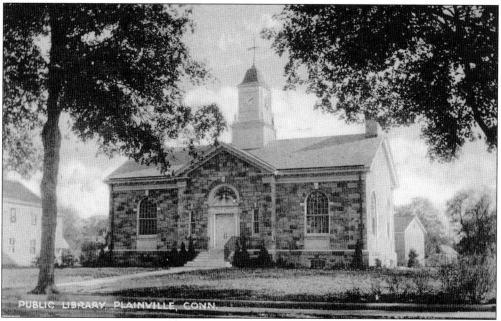

The Plainville Library, originally known as the Farmington Plain Library, was incorporated in 1823 with 18 proprietors. The West Plain School house was used and only opened certain days a week. In 1855, the books were sold, with the surviving proprietors receiving the proceeds. The Plainville Library Association was organized in 1885. A reading room on the second floor of the George L. Newton building opened in 1885. The Plainville Town Hall was next, until the fire of 1917. The books were moved to the Grange hall and then West Main Street. The above building was opened in 1931.

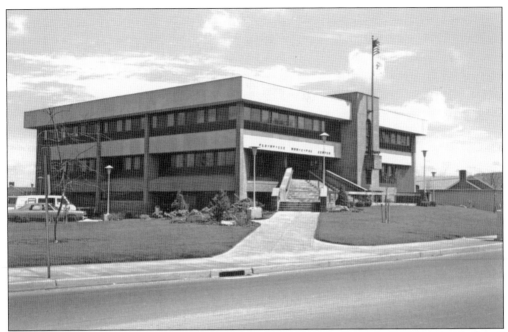

The municipal center was opened on December 17, 1973. It was made up of the town hall and the police department. Prior to this building, the town hall was at 29 Pierce Street and the police department was on Stillwell Avenue. In 1976, the old town hall was given to the new Plainville Historical Society and known as the Plainville Historic Center.

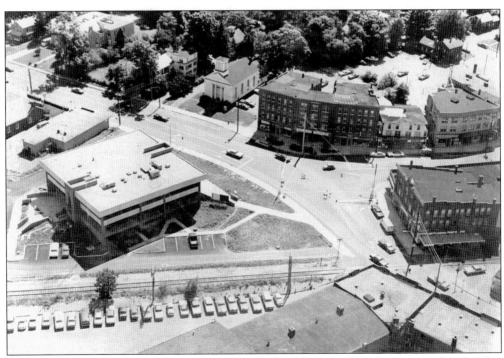

This is an aerial view of the municipal center on the left. In back is the Baptist church, Neri Block, and on the right in front is the Russell Block.

Eight
Changing Times

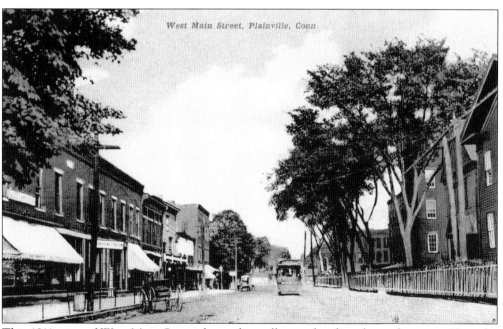

This 1911 view of West Main Street shows the trolley car heading down the street. Note the wagons on the left along the curb and the awnings on the stores. On the right, the fence went from Pierce Street on to West Main Street all the way up the street in front of the Plainville Knitting Mill buildings.

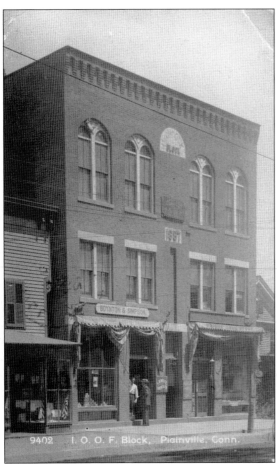

In 1887, Merritt B. Hitchcock constructed this building that became known as the Odd Fellows block. The first floor originally had two businesses in it. On the left, in 1888, Leland and Meder from Bristol opened a clothing store, and on the right was Hitchcock carriage sales room. The third floor of the building became the meeting place for the Order of Odd Fellows in 1902. The second floor became their club room in 1915. In this 1912 picture on the left was Boynton and Simpson clothing store and Prior's Drug store on the right.

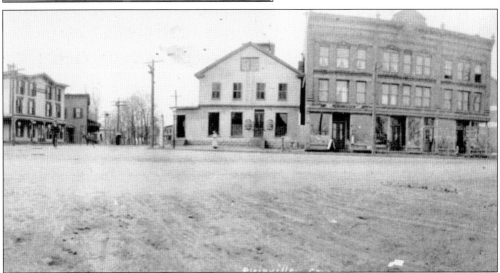

This is Plainville center around the 1920s. On the left is Hotel Clarendon on Whiting Street. The center building is James Murphy's Saloon. A barbershop operated by Alphonse Bordeau is on the right. The brick building is the Russell Block.

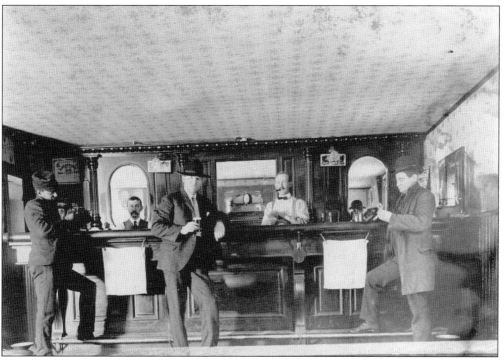

This 1907 interior picture is of James Murphy's Saloon that was in Adna Whiting's old general store, built in 1831, during the Farmington Canal days. Note the tin ceiling in the picture.

THE SWEETEST THING IN GLASSES,
NEW ENGLAND BEER AND ALE.
It Looks Good, It Tastes Good, It Is Good!

J. J. MURPHY'S Cafe

ALSO HEADQUARTERS FOR

Robert Smith's Stock Ale, and Sherwood Whiskey.

Plainville, Conn.

This business card is promoting James J. Murphy's café around 1905.

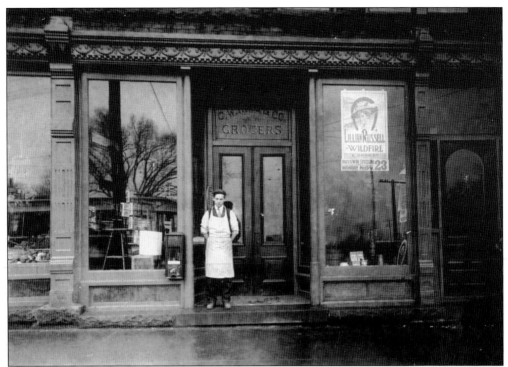

In 1895, Thomas G. Russell built a three-story brick building facing Central Square next to Adna Whiting's store. One of the first businesses there was a grocery store owned by Charles W. Hird. In the above picture is the next owner, John Eastwood, who kept the business under the same name Charles W. Hird and Company.

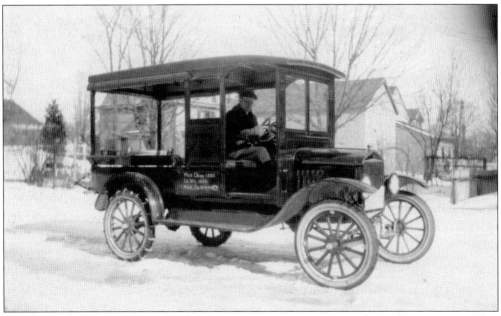

When Charles W. Hird first started delivering groceries, it was in a horse-drawn wagon. This 1917 picture shows one of the first delivery trucks that the Hird business used.

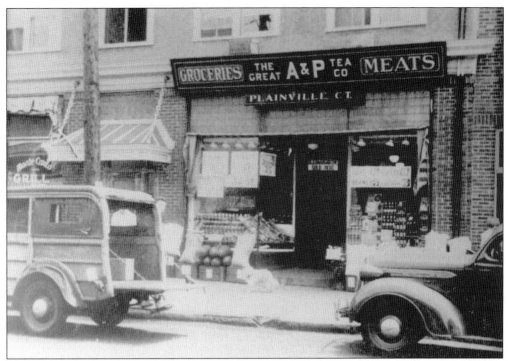

Franklin P. Frisbie and Willis J. Hemingway formed a partnership in 1883 and opened a grocery store at 18 Whiting Street. Next the Great Atlantic and Pacific Tea Company opened here in 1914. After managing in various A&P grocery stores, Harry Petit became the store manager in 1937.

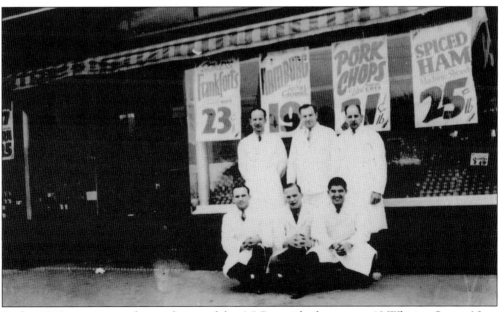

In this 1940s picture are the employees of the A&P outside the store at 18 Whiting Street. Note the prices of meat advertised in the window behind them.

Harry J. Petit was born in Bristol in 1805. He started in the grocery business in 1942 on West and Gridley Streets in Bristol. Harry took over the business when his brother Lewis went into the service. In 1936, Harry and his family moved to Plainville. After 25 years of managing in various towns for A&P, Harry went into the grocery store business and ended up with nine stores. All nine of his children worked in the stores. In this picture taken in the Bristol store are, from left to right, Harry Petit, a representative from the S. and W. Foods Company, and Harry's brother Lewis.

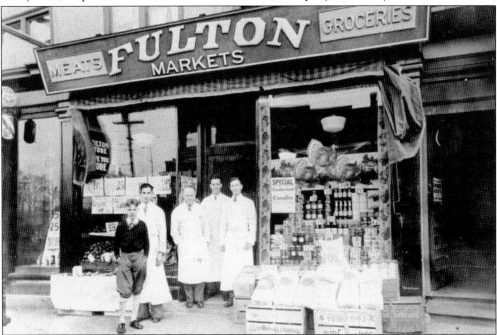

This 1927 picture is of Fulton Market on 77 Whiting Street. Employees in their aprons stand with fruit in crates on the sidewalk, and canned goods are on display in the windows.

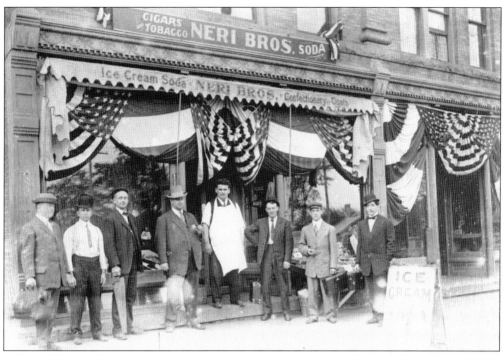

Nulo and Regulo Neri started their confectionery store in 1906 in the Russell Block building on West Main Street. Standing in the doorway in the apron is Joe Neri.

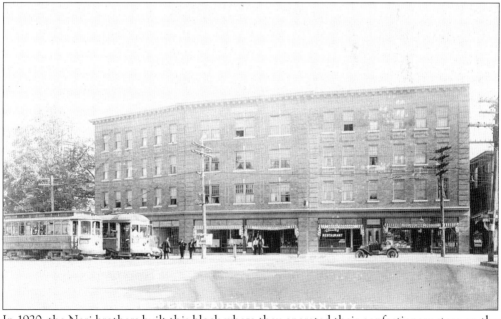

In 1920, the Neri brothers built this block where they operated their confectionery store on the far right. There were also a barbershop, drugstore, and restaurant. The upstairs were apartments. Note the trolley cars on the left.

In this early-1900s picture is East Main Street near Central Square. In front is a horse-drawn wagon at Morgan's Lunch restaurant.

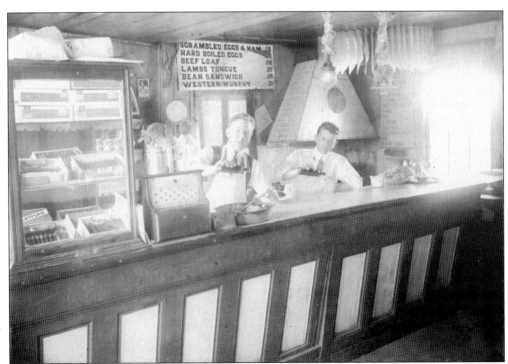

This is the restaurant called Gleasen's Quick Lunch that took over after Morgan's Lunch located on East Main Street. In its place today is the Old Canal Veterinary business.

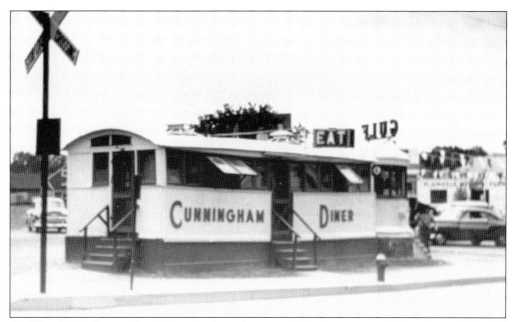

On West Main Street, Frank Cunningham first started his business in 1927 in front of the old Plainville Knitting Mill. He moved his business to this location when the mill was going to be torn down. His son Francis "Franny" took over the business in 1959. It soon became the local place to go, especially for the local politicians to discuss town business.

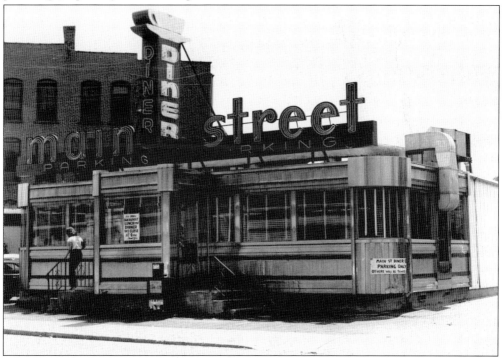

The Main Street Diner was purchased by Franny Cunningham in 1959. The diner came from Hampstead, Long Island, New York. It was located on Main Street. This diner, a popular place to eat, still stands today in the same location on West Main Street, which was once Main Street.

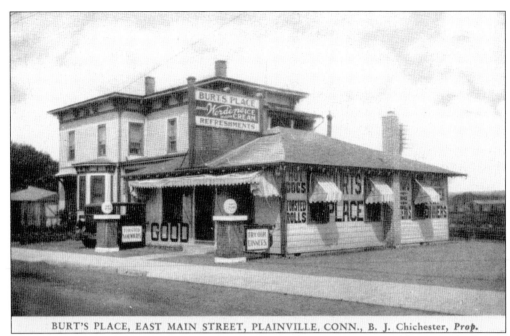

Located on 97 East Main Street, Burt's Place was a popular restaurant owned by Burt Chichester. The restaurant was famous for its fried clams.

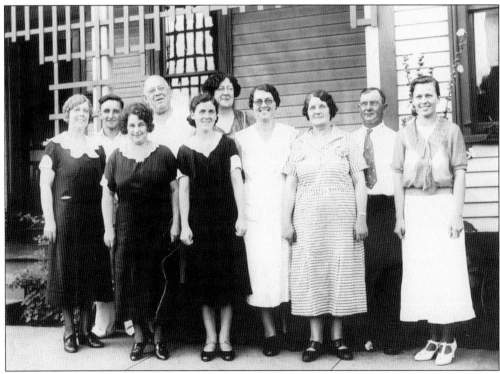

In this 1935 picture are the employees of Burt's Place. From left to right are Mae MacDonald, Learned Cottrell, Julia Bottomly, Burt Chichester, Myrtle Chichester, Margaret Furber, Lottie Coe, Mrs. Peace, Judd Wadsworth, and Barbara S. Wazorko.

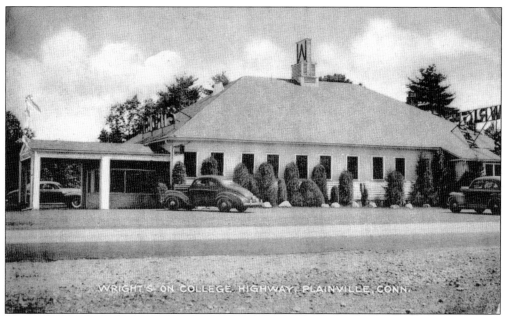

Wright's Tavern, located at 290 Farmington Avenue (formally known as the College Highway), was not only a popular restaurant but was also a place where entertainers performed.

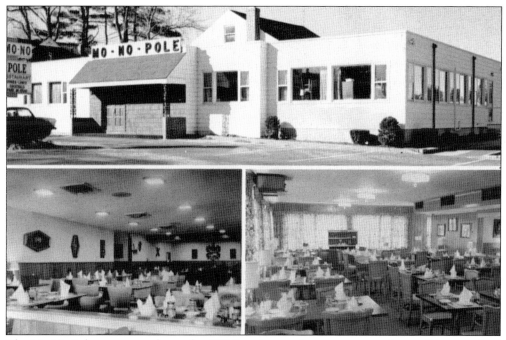

The Mo-No-Pole restaurant, located at 393 Farmington Avenue, was another well-known place for families to go. When new owners bought the business, the restaurant name was changed to Confetti's Restaurant.

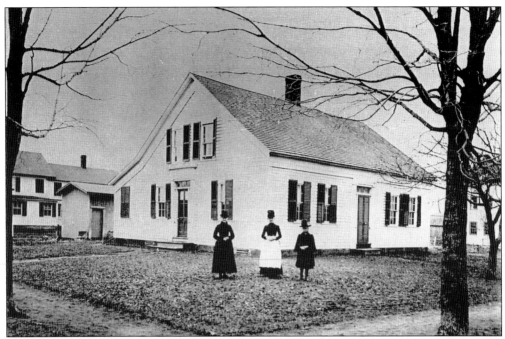

In 1830, this building located at 80 Whiting Street was the old Rizzo store. It was on the corner of Broad and Whiting Streets.

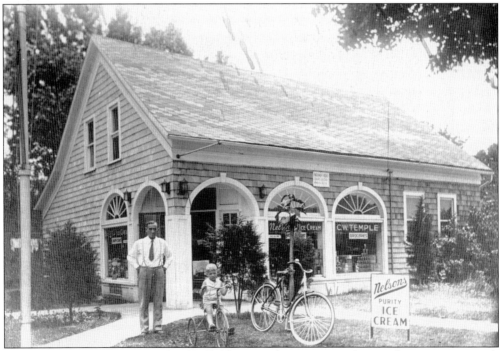

This is the building that was formally the Rizzo store 100 years earlier. In this 1930 picture are Clarence Temple and Vern Hunter Temple. The business was C. W. Temple Groceries. Later the business changed to Sunset Dairy Store. The building still stands today.

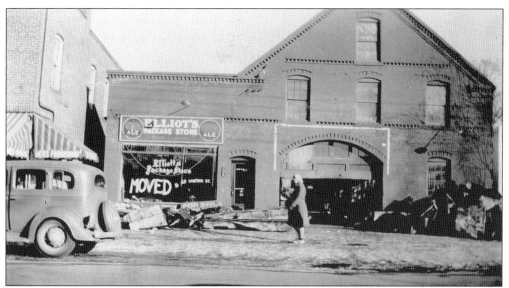

Elliot's Package Store, on the left, and Economy Coal and Oil Company, on the right, were located at 32 Whiting Street near Petit's building. The package store was owned by James H. Elliot, and the coal and oil was owned by John O. Elliot. Now there is a flower shop and doctor's office, with apartments over, in the stores that were built by Bill Petit.

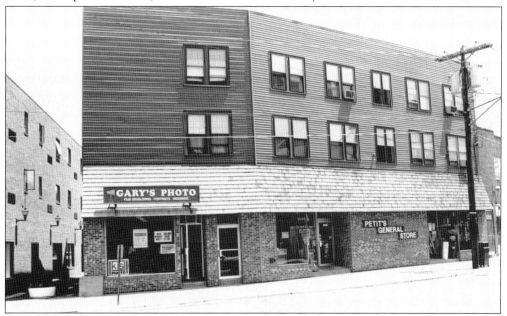

At 36 Whiting Street this building dates back to 1895. Bill Petit's father, Harry Petit, opened a supermarket in the 1940s where Central Café is now. In 1967, Bill and his wife, Barbara, along with his brother Charlie and his wife, Marilyn, started P. and P. Market Incorporated, opening up the Shopping Basket. It was a grocery store in the same place where their father's store had been. In 1973, the Petits bought the old five-and-dime store that became Petit's General Store. The store has gone through many changes with downsizing from a department store to a convenience store. After 32 years in business, Petit's General Store closed in 2005 when Bill and Barbara Petit retired.

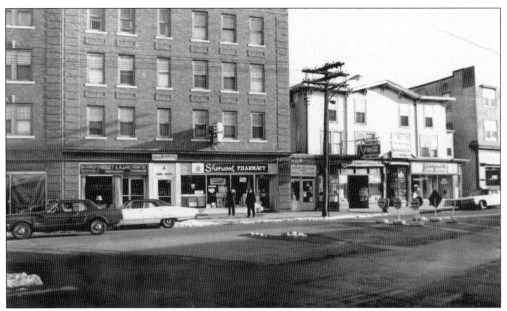

In this 1968 picture of Whiting Street, in the Neri brothers building on the left, is the business of Kane and Nichols. Violet Kane ran a secretarial agency and attorney Arthur Nichols had his law practice. On the right was the business Sherwood Pharmacy.

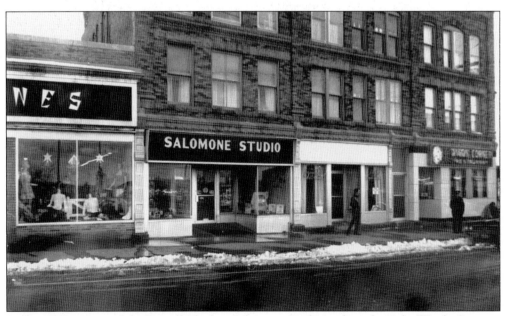

In this 1968 picture of the Russell Block is Salomone Studio and on the right Windy Corners. On the far left is Garfield Jones clothing store in the old Whiting Building.

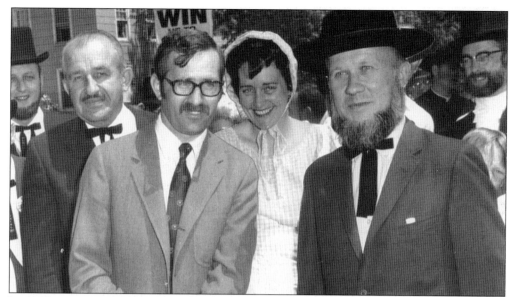

In 1966, a committee formed to plan the town of Plainville's 100th anniversary. It became known as the centennial celebration. Some of the committee members were Gertrude Nystrom, Kenneth Hedman, Edith Mourey, Sylvia Millerick, and Howard Usher. Some of the events included a house tour; an arts and crafts show; men, women, and children wearing Colonial-type clothing, with men growing beards; a parade; and a time capsule. June 7, 1969, was the official start of centennial week with town manager Edgar E. Maroney cutting the ribbon. From left to right are town councilmen Paul Mazur and Elizabeth Zebrowski and town council chairman Fred Heorle.

Shown is the arts and crafts show ribbon cutting during the Plainville centennial week. From left to right are Cynthia Smagacz, Melinda Rogers, Ruth Hummel, Howard Usher, Bill Petit, Joseph Puligese, Herbert Browne, and Chet Sutherland.

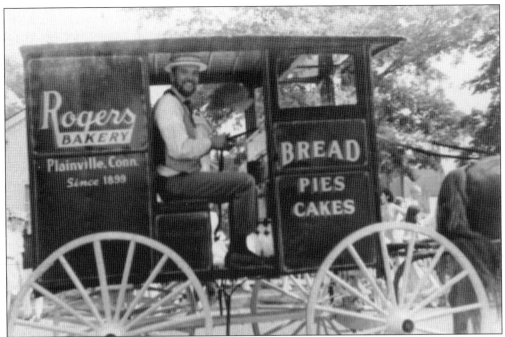

One of the events during Plainville's centennial week was the parade. The parade was held on Saturday, June 14, 1969, on the last day of events. There were 11 divisions that started at Linden Street School and ended at Norton Park. In the above picture is the only wagon left from Rogers Bakery. The wagon is now at the Plainville Historic Center on display.

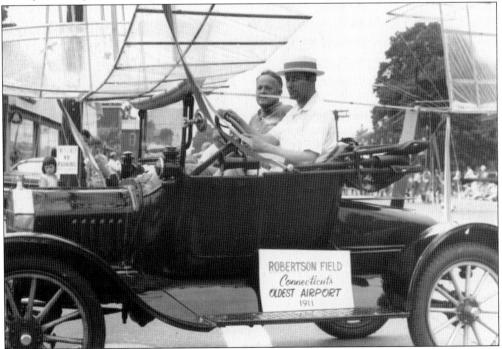

Robertson Airport, the oldest airport in Connecticut, starting in 1911, added wings and tail to this antique car for the parade.

Posing in Colonial wear are Bob and Ruth Sharp Hummel during centennial week. They were involved with most of the events that took place from June 7 to June 14, 1969.

The Kiwanis Club contacted the Smithsonian Institute as to how to plan which items would go into the time capsule. Edith Mourey editor of Plainville news for the *New Britain Herald* newspaper worked on material to go into the time capsule. Special paper was available for messages to be put on by local residents. The capsule will be opened in the year 2069. From left to right are Kiwanis member George Foley, Bruce Whitcomb of Elmore Vault Company, and Bob Bailey from Bailey's Funeral Home, who donated the vault on June 14, 1969, in front of the Plainville Library.

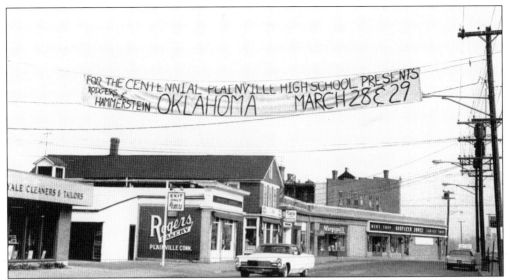

This 1969 picture of Whiting Street taken in March shows, from left to right, Yale Cleaners; Rogers Bakery; Margonelli's Paint and Wallpaper that was owned by Tony Sileo; and Garfield Jones clothing store.

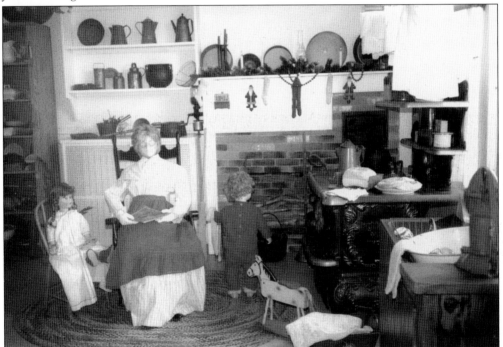

The Plainville Historical Society was created as a result of the Plainville centennial celebration in 1969. In 1973, the society received the use of the original Plainville Town Hall that was built in 1890, which the town was no longer using. The volunteer members fixed the building, creating various rooms with donated items from Plainville's past. This picture shows one of the rooms located on the second floor. It is a Colonial kitchen decorated with items such as tinware that came from town. The Plainville Historical Society plays an active role in preserving Plainville's past.

Nine
Social Clubs, Organizations, and Entertainment

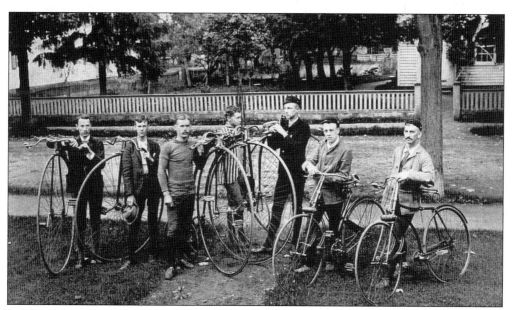

In May 1888, a group from the Plainville Bicycle Club is ready to take a ride to Meriden. From left to right are C. B. Potter, Louis Hitchcock, Walt Seymore, C. L. Clark, Arch Bradley, C. G. Bassett, and Joe Williams.

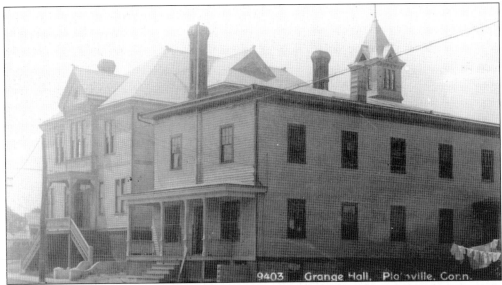

The Grange hall was built on Pierce Street on land bought from the estate of Edwin Hills around 1910. The materials to build it came from a school in Forestville Center. An addition to the hall was done in 1929. The building was used for fairs and agricultural exhibits. Dinners were family oriented, charging a slight fee for the meals. Members paid dues to belong. The Grange stood next to the Plainville Town Hall until 1955, when it was sold and later torn down.

This group of actors from a comedy plays at the Grange hall around 1940. From left to right, they are (first row) unidentified, Lottie Newell, Veronica Carter, and Ellen Taylor; (second row) Doris Furrey, Gertrude Barnes Stillman, Irving Carter, Bill Wilbur, Frank Hartford, Edna Burns Jester, and unidentified; (third row) Herman Simonson, Floyd Stillman, Charles E. Weldon, and Herold Newell.

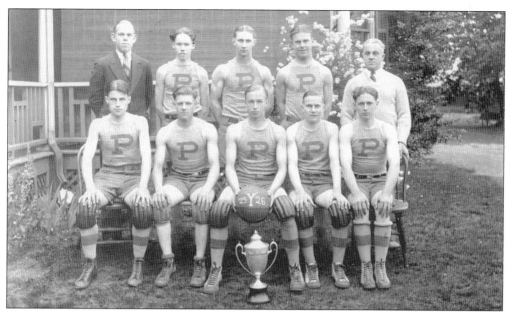

The above picture is the 1925–1926 Plainville YMCA men's basketball team. From left to right are (first row) Trafton Getchell, Ralph Arnold, Loyal Smith, Wesley "Cookie" Schwab, and Douglas Martin; (second row) Raymond Morrill, Martin Bergen, Fred Miller, Ray Schwab, and Walter Allen Bailey Sr.

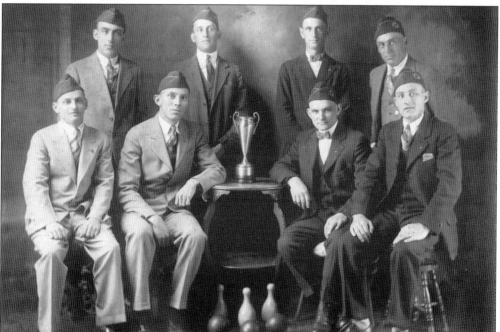

The Brock-Barnes Post No. 33 of the American Legion started on July 16, 1919, meeting at the Independent Order of Odd Fellows (IOOF) Hall on West Main Street. The post name came from the first war nurse and soldier to die in service for their country. In this 1927 picture, from left to right, are (first row) S. Burgiel, J. Paul, "Doggie" Saundens, and ? Brookes; (second row) E. Brookes, Harlan Burgess Sr., Jack Fletcher, and Ted Fanion.

Frederick Lodge No. 14, AF&AM, was chartered by the Grand Lodge of Massachusetts Bay on September 18, 1787. Originally part of Farmington, the first members from Plainville were John Cooke and Calvin Lewis from the White Oak section of the Great Plain. The first meetings were held at the home of John Mix in Farmington until 1834. Frederick Lodge closed in 1852, giving up its charter to the Grand Lodge. In 1860, the charter was restored and meetings were held at Newton's Hall. In 1874, the charter was surrendered again and restored in 1876, meeting over at Adna Whiting's store. In 1887, the lodge met at the new Hitchcock building later known as the Odd Fellows Block. June 15, 1912, was the dedication of the new Masonic lodge on 70 East Main Street. In 2002, Franklin Lodge of Bristol joined Frederick Lodge, changing the name to Frederick Franklin Lodge No. 14, AF&AM.

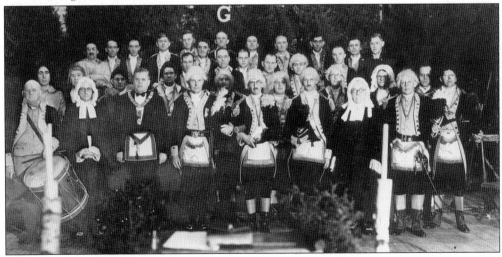

This picture was taken during the George Washington Communication with some of members of Frederick Lodge and some from the Grand Lodge of Connecticut. In the front row from left to right are drummer Adrian Smith, chaplain Henry A. Castle, grand master Raymond, master John H. Trumbull, Benjamin E. Getchell, John B. Miner Jr., grand chaplain Rev. Robert E. Burton, Stanley S. Gwillim, and Harry Tredennick.

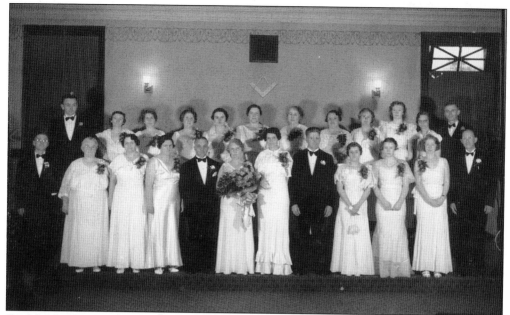

On May 9, 1936, a special session of the Grand Chapter of Connecticut, Order of the Eastern Star, was held at the Masonic temple in Plainville for the purpose of instituting Frederica Chapter 110. Their meetings were held in the Frederick Lodge No 14, AF&AM, on the second and fourth Wednesday of each month. In the above picture are the charter members of Frederica Chapter 110. The members continue to meet in Frederick Franklin Lodge.

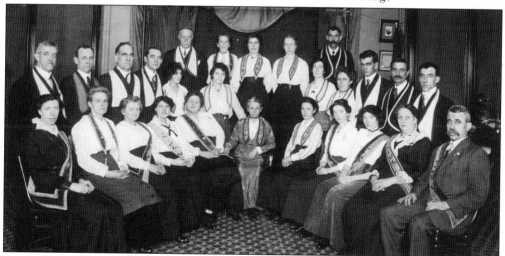

Martha Rebekah Lodge No. 45 was organized in 1896 and instituted on April 29, 1896. There were 35 original members with nine affiliates from other lodges where they had previous memberships. They met in the Hitchcock building on West Main Street later known as the Odd Fellows block. In the above picture taken in 1914 are (first row) Jennie Colman, Udell Thompson, Martha Buys, Arta Gilbert Johnson, Elizabeth Gilbert, Antoinette Warner, Minnie Pease, Mabel Coleman Bailey, Lura Minor Sceery, Laura Minor, and George W. Buys; (second row) David Coleman, Winifield S. Pease, Edward L. Morse, Ralph W. Morrill, Ruth Warner, Edna Warner Millard, Frank Gilbert, and William Bailey; (third row) Wallace W. Beach, Lulu Pease, Anna S. Vance, Ella Morrill, and Hayden W. Griffin.

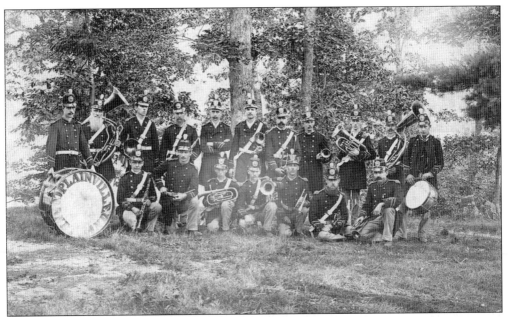

The Plainville Cornet Band was organized in 1872. Each member contributed to a fund to purchase musical instruments. Their uniforms were made to order for each member. The band was used for every public and private function. The band disbanded in 1912 due to a lack of musicians.

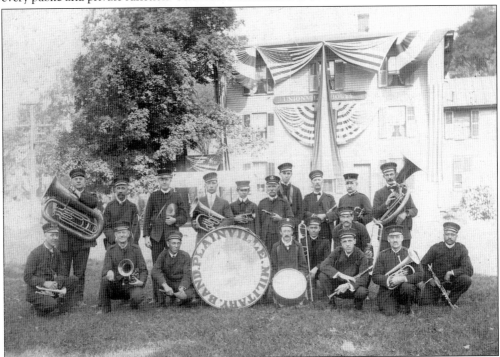

The Plainville Military Band was formed on November 7, 1871, by John Kennedy and E. C. Hamlin. Members are (first row) William Fox, Fred Lewis, George Newman, Sandy Woodford, Harry Stilman, William O'Neil, Eugene Thorpe, and Joseph Dey; (second row) Irving Shubert, George Buys, Ralph Warfield, Eddie Banyon, Morris Williams, and Wells Taylor.

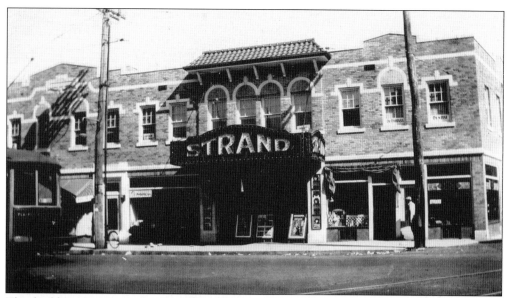

This building, known as the Strand Building, on West Main Street was completed by George LeWitt in 1927. The Strand Theater grand opening was on February 25, 1927. It was invitation only, with Gov. John H. Trumbull, Plainville town officials, and prominent businessmen in attendance. In the 1930s, the cost of a ticket was 10¢ or 25¢. Housewives enjoyed the dishes they would get as part of their admission from various merchants. The theater was closed by 1960, when White Oak Excavators put an addition on the old theater for their offices and repair shop.

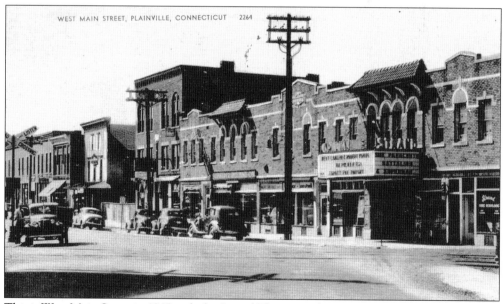

This is West Main Street in 1945 with the Strand Theater and various retail stores surrounding it.

This pond located in Paderewski Park started as Leland C. Hart's sand quarry. Located off Cooke Street on around 36 acres, the property was purchased by Rev. Lucien Bojnowski, the pastor of the Roman Catholic Church Sacred Heart in New Britain in 1940. He named the park after the famous Polish pianist Ignace Jan Paderewski. This picture shows the pond in 1969.

When Paderewski Park was dedicated in 1941, the Daughters of Mary of the Immaculate Conception ran a camp there for youngsters. This building was one of two dormitories at the camp.

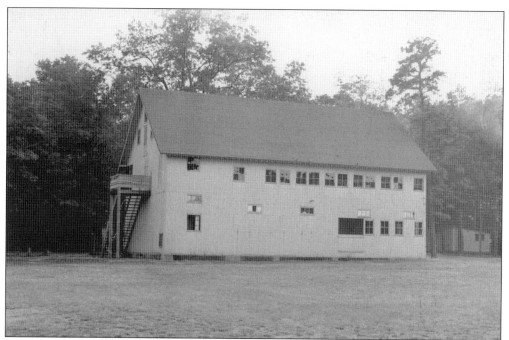

In this building at Paderewski Park was the youth center. There was also a pavilion and a small chapel. When the park started to deteriorate by the early 1960s, the town of Plainville, in 1966, took the title of the park and started proceedings to take over. Paderewski Park provides fishing, baseball, picnics, and in the winter, skating on the pond.

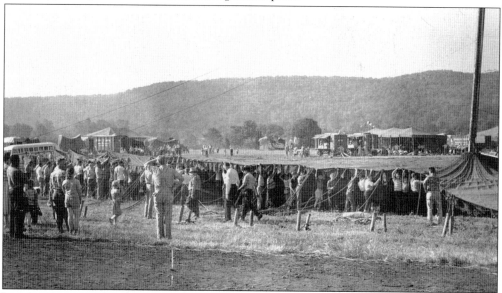

Joseph Tinty owned a furniture store in New Britain that he started in 1935 with his wife, Mary. In 1942, he purchased from Carina Audett 65 acres of land on New Britain Avenue. He bought 20 more acres in 1957 from Charles and Ora Relay. It became known as the Plainville Stadium. In this 1950 picture, the Ringling Brothers Circus is setting up its tents. After the Hartford Fire in 1944, Tinty had to convince the circus to come to Plainville. That first year was so successful, the circus came back for many years.

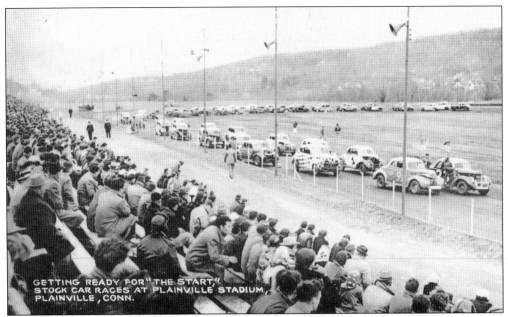

The Plainville Stadium became a popular place for fun throughout the state. Along with the stock car races, there were rodeos, motorcycle racing, and beauty pageant contests.

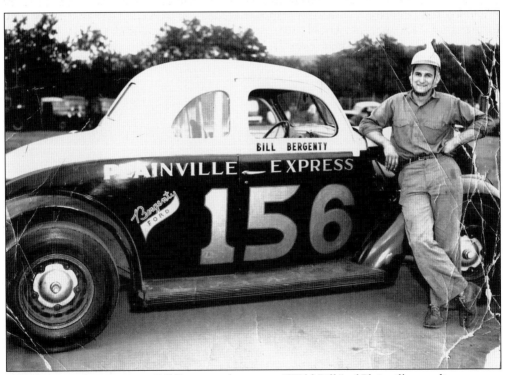

The driver in this picture is Bill Bergenty, known as "Wild Bill," of Plainville standing next to his stock car at the Plainville Stadium.

When Joe Tinty was 66 years old, he turned his furniture store, Tinty's, over to his son Donald. Joe put on a cowboy outfit and started performing with his palomino horse Sugarfoot. He enjoyed performing tricks for the children. Tinty died at the age of 96 in 1997.

Along with the Plainville Stadium, Joe Tinty built a drive-in theater in the 1950s. He then built a 17.5-acre plaza called Red Oak Plaza. It included the Roller Palace Skating Rink, the Stadium Lanes Bowling Alley, and a Grants Department Store, and later a fish market. All the property was torn down in 1990 to build a mall called Connecticut Commons.

ACROSS AMERICA, PEOPLE ARE DISCOVERING
SOMETHING WONDERFUL. THEIR HERITAGE.

Arcadia Publishing is the leading local history publisher in the United States. With more than 3,000 titles in print and hundreds of new titles released every year, Arcadia has extensive specialized experience chronicling the history of communities and celebrating America's hidden stories, bringing to life the people, places, and events from the past. To discover the history of other communities across the nation, please visit:

www.arcadiapublishing.com

Customized search tools allow you to find regional history books about the town where you grew up, the cities where your friends and family live, the town where your parents met, or even that retirement spot you've been dreaming about.